here

there

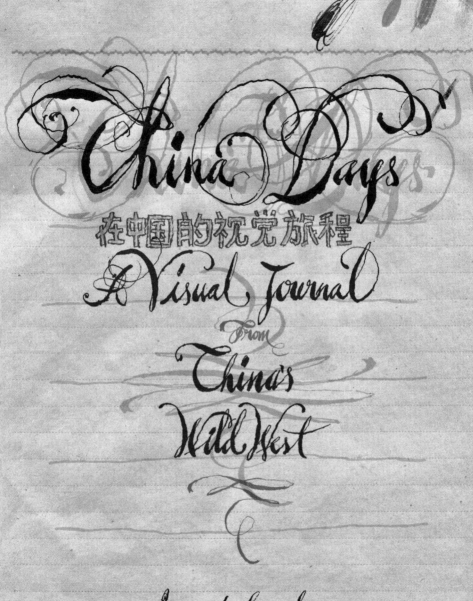

China Days

在中国的祝完旅程

A Visual Journal

from

China's

Wild West

henrik drescher

CHRONICLE BOOKS
SAN FRANCISCO

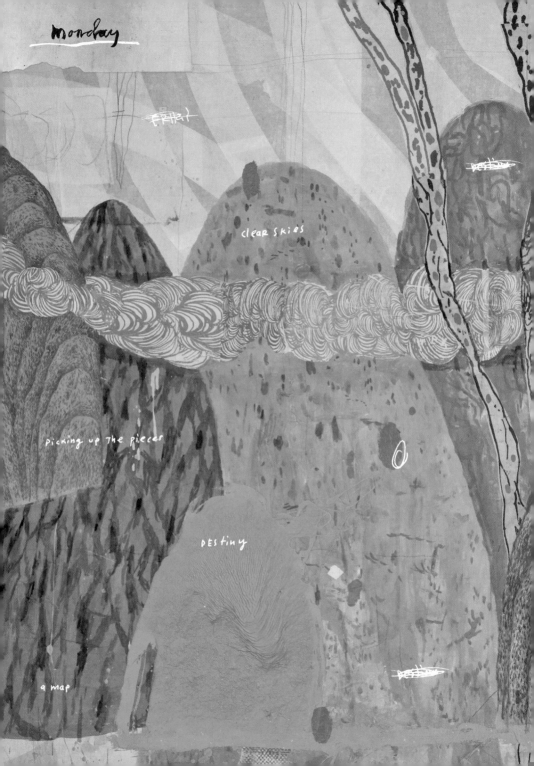

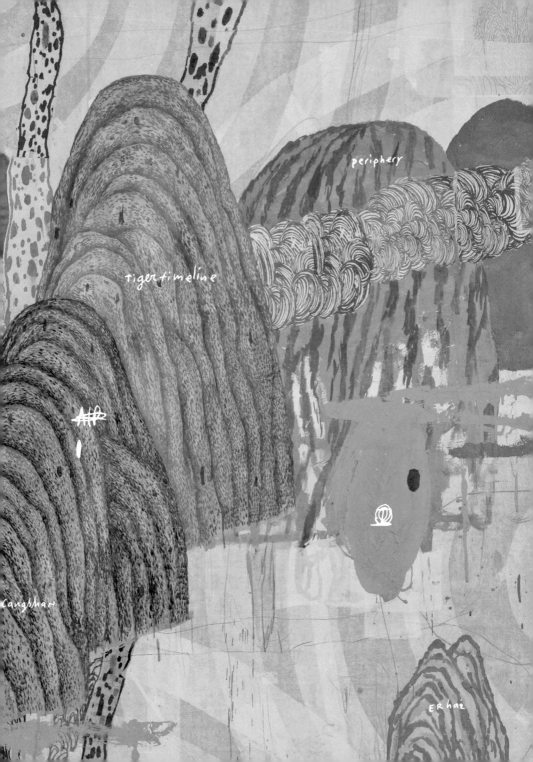

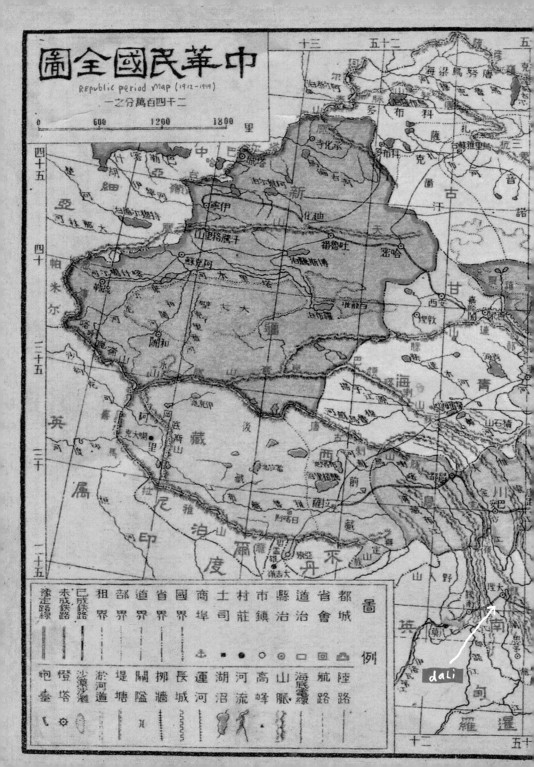

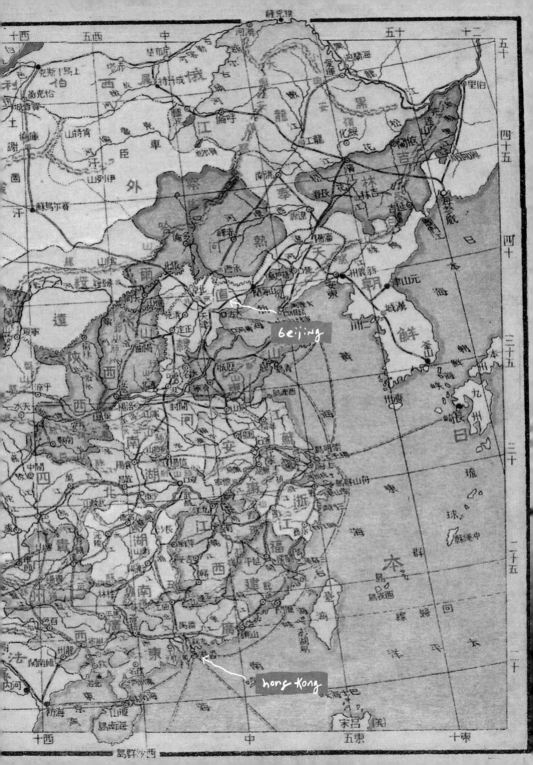

One scorching spring afternoon in 2002, my wife, Wu Wing Yee, and I boarded a sleeper train from Guangzhou's chaotic central station for a twenty-seven-hour journey to Yunnan province. Our idea was to make a one-month escape from the fetid heat of the Guangzhou, where we lived, to the high, arid mountains of southwestern China.

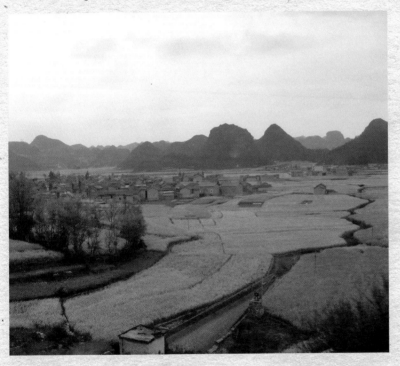

The next morning, looking out the windows of our rumbling train, I saw for the first time the mountains of Guizhou: they jutted up like huge anthills between flowering rapeseed fields. In my mind these impossible mountains existed only as artistic inventions on ancient scrolls.

This proved to be the beginning of a long series of eye-opening, mind-popping experiences in my new China life.

Dali, Yunnan, lies between the Cangshan Mountains and Lake Erhai. The province borders the countries of Burma, Laos, and Vietnam, and has for decades been a refuge from the oppressive overcrowding and pollution of Chinese urban life.

As an artist I've tried to make it a priority to live in places that offered me the two most valuable resources for creativity: *time and space*.

In Dali, Wing and I found both.

The clean, dry air and sun-filled days lulled us into a hypnotic rhythm of work and play unequaled anywhere we'd lived before. In the blink of an eye, our one-month holiday morphed into an eleven-year relationship with the verdant mountains of Yunnan.

When we first arrived, we stayed in hotels and guesthouses, usually renting two rooms, one to sleep in and one to work in. Gradually we upgraded to a rented courtyard house, and for a time we lived in a storefront, until finally, in 2005, we bought and renovated a small two-story town house.

Dali is home to the Bai cultural minority. More than a millennium ago it was the independent Bai kingdom of Nanzhao, which lasted for less than two hundred years before it fell. A few centuries later, Kublai Kahn conquered this region, absorbing it into the Yuan dynasty.

Today Dali is defenseless against the invading hordes of tour groups and backpackers on the granola trail, looking for their own private Shangri-la. Actually, the "real" Shangri-la can be found only eight hours' drive north of Dali and is usually the next stop after visiting the hyper-touristy town of Lijiang.

In the dozen years we've been connected to Dali, it has shed its skin numerous times: old farmhouses torn down to build new fake old-farmhouse-tourist-malls, electric tourist buses introduced to haul exhausted tour-bus groups around town quickly, leaving enough time to get to Lijiang in time for shopping and dinner.

Besides the tour-group onslaught, Dali has experienced a steady migration of people from big, polluted metropolises looking for a cleaner, healthier lifestyle.

The upside to this phenomenon is that with the arrival of these new residents, bookshops, cafés, and restaurants have sprouted up around town, which make life a bit easier for people like us, but at the same time make me hate people like us.

China is a living paradox. It is the richest and the poorest place on the planet. It is ancient and it is ultramodern. There is a tenderness and debt to people that harkens back to antiquity, and at the same time it is hopelessly infested with corruption, greed, and cruelty.

In my time here I've attempted to be an observer and a participant. I have probably been most successful at the former—the language has always been a struggle for me, and observation is in my blood. My work, whether it be illustration, edition books, or painting, has always been about absorbing and documenting existence.

It is my hope that this little book somehow manages to reflect a handful of the numerous facets of this great place.

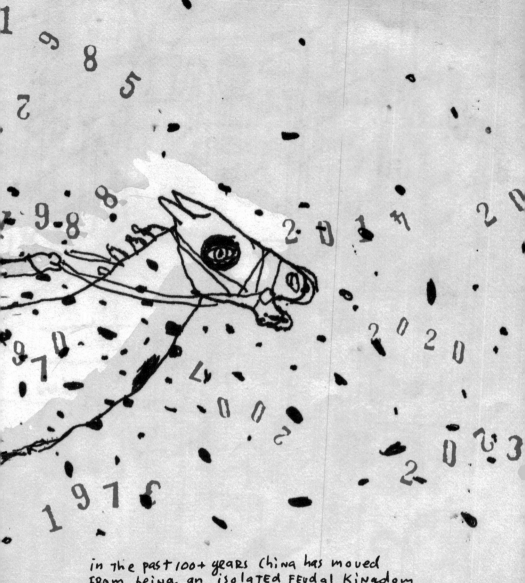

in the past 100+ years china has moved
from being an isolated feudal kingdom
towards modern statehood.
in the past 30 years alone, it has raced from
being a totalitarian communist dictatorship
to a kind of hybrid totalitarian capitalist
dictatorship. things here happen so fast it's
impossible to predict what the future will bring.

China timeline

Cultivation
of RICE 10,000 b.c

xia
2070 → 1600

3 Sovereigns
+ 5 emperors
2852 → 2070

3000 bc

2000 bc

1500

shang
1766 – 1226

zhou
1046 – 256 b.c

han
206bc
220ad

Qin 221 – 206 b.c →

1800bc

500bc

china's RECORDED history dates back 4000 years,
however Evidence of civilization has been
found as far back as 10,000 BC.

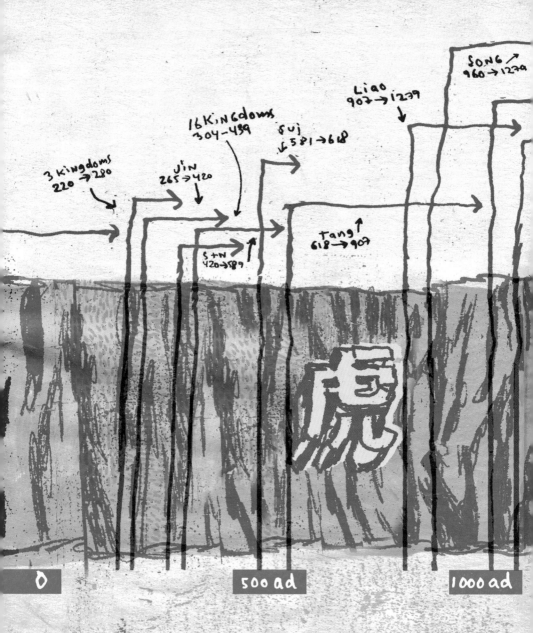

3 kingdoms
220→280

Jin
265→420

16 Kingdoms
304→439

Sui
↓ 581→618

Liao
907→1279

SONG ↗
960→1279

S+N
420→589

Tang ↑
618→907

0

500 ad

1000 ad

China's latest "DYNASTY," The PEOPLE's REPUBLIC occupies ONLY The tip of The tiger's left ear and The "Discovery" of AMERICA by Columbus Falls somewhere around its shoulder blade.

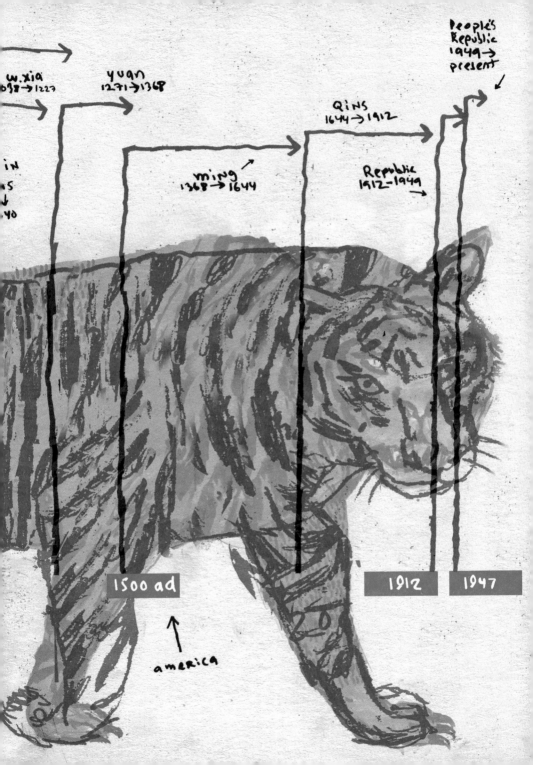

w.xia
1038→1227

yuan
1271→1368

in
s
↓
40

People's
Republic
1949→
present

Qins
1644→1912

ming
1368→1644

Republic
1912-1949

1500 ad

1912

1947

america

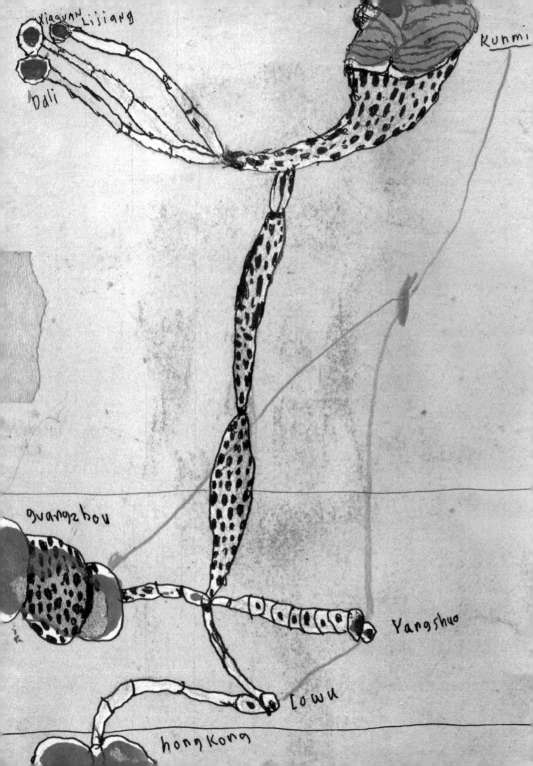

NIGHTSWEATS FUELING

DAYDREAMS

There is something creatively liberating
about being stuck on a train for 27 hours.
day melds into night, boredom morphs into creativity
like a state halfway between awake and slumber.

moving westward from China's bustling
East coast. Feels more like Time Travel
than Train Travel.

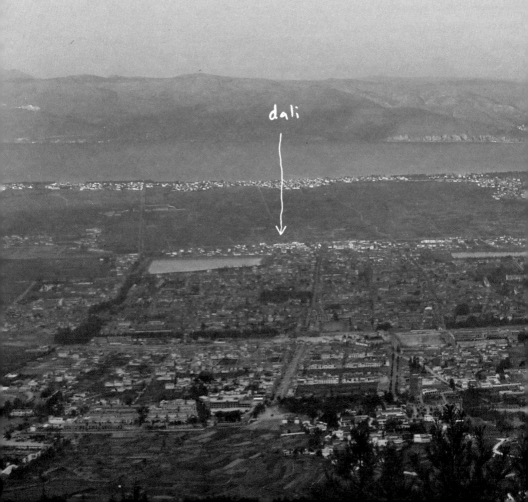

dali

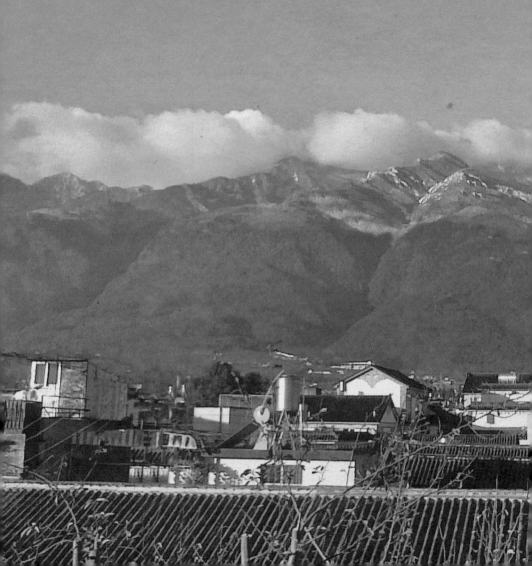

the cangshan mountain Range rises to 12,000 Ft,
in the past monkeys and tigers Roamed its forests,
now one is more likely to spot a mushroom hunter
or pinenut gatherer... or a german tourist
ascending its peak in one of the newly installed gondolas.

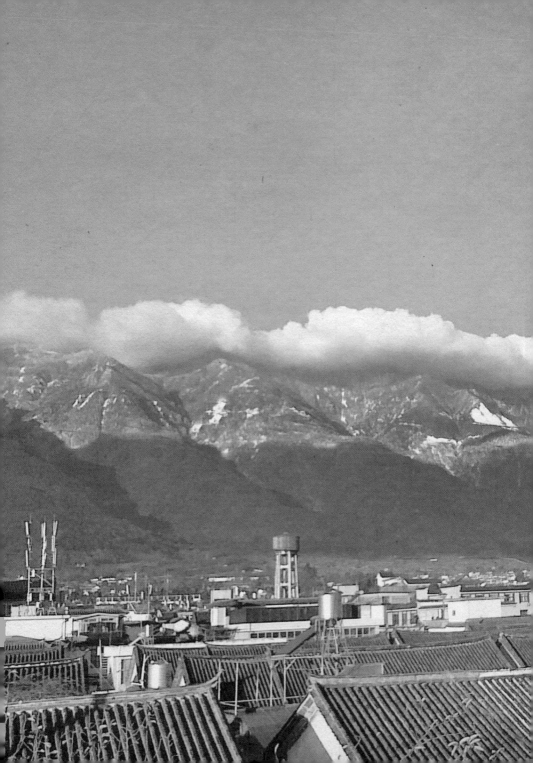

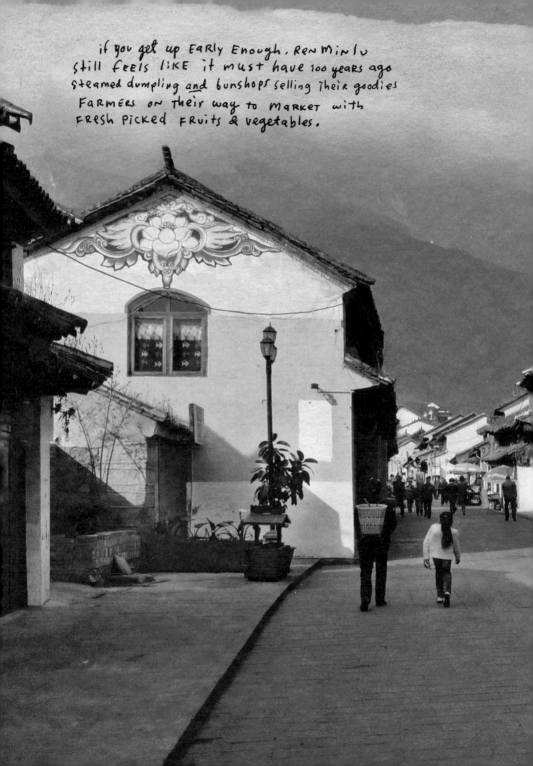

if you get up EARLY Enough, REN Min Lu
Still feels like it must have 100 years ago
Steamed dumpling and bunshops selling Their goodies
FARMERS on Their way to MARKET with
FRESH PICKED FRuits & vegetables.

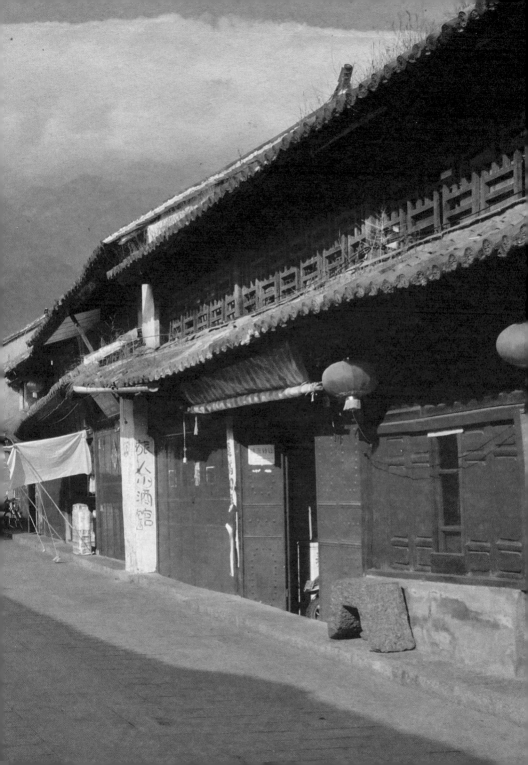

Tuesday

Tibetan Cowboy

Radiant Exuberance

KEYS

Demolition

MR. Yang's Barbershop

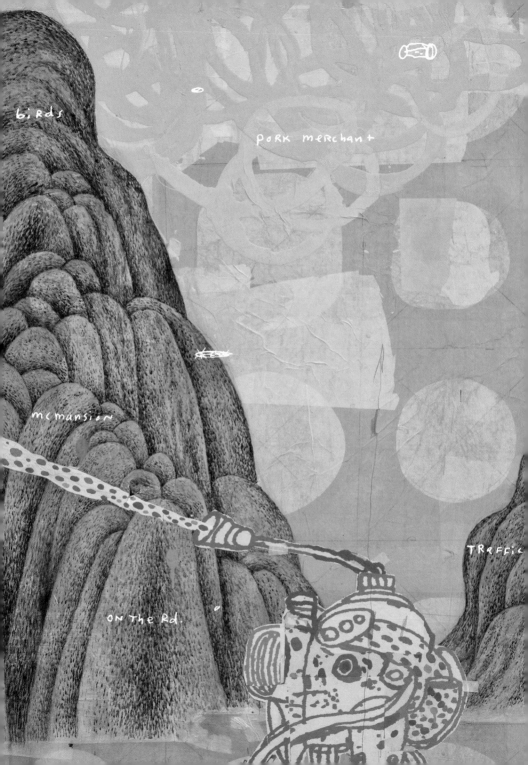

birds

PORK MERCHANT

mcmansion

TRaffic

ON The Rd.

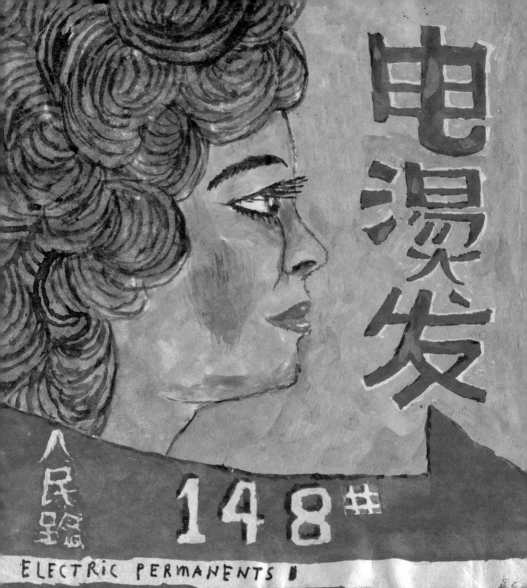

电烫发

人民路 148#

ELECTRIC PERMANENTS

Visiting barbershops is a great way
to get a feel for a place.
My favorite shop in dali is
mr. yang's on RENMIN lv.
his sign advertises "ELECTRIC PERMANENTS" (yes, Electric!!)

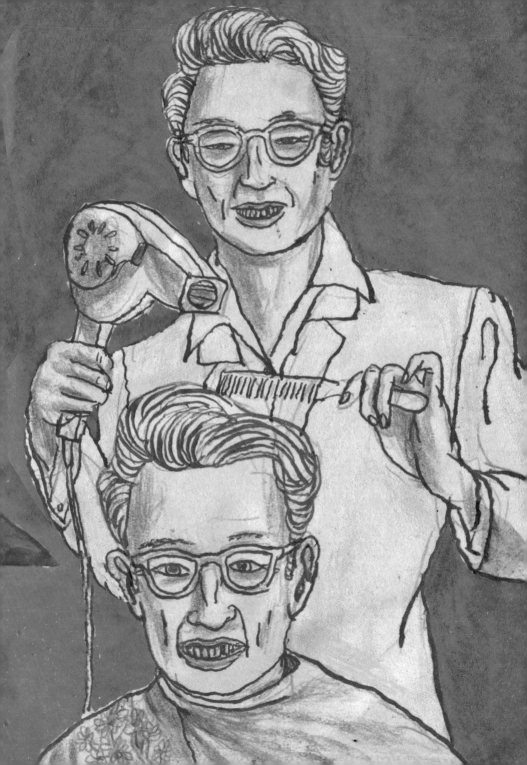

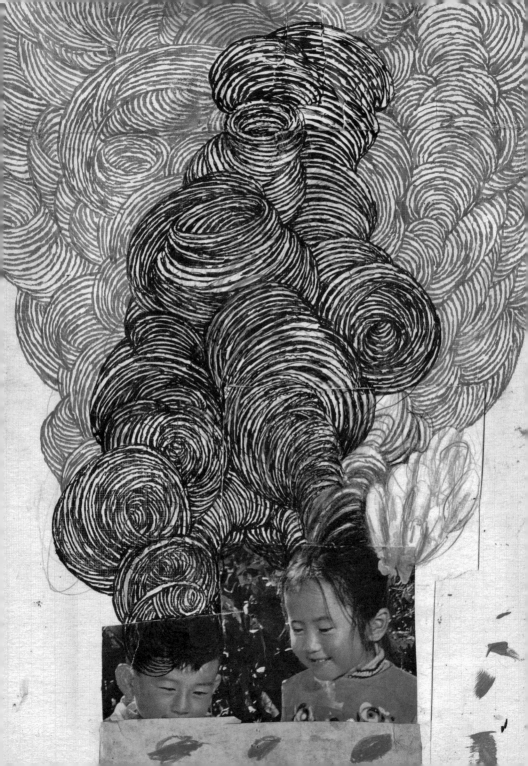

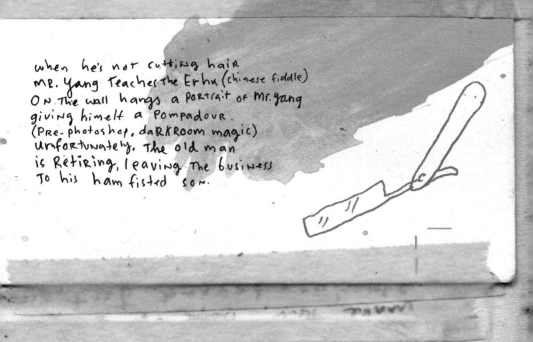

when he's not cutting hair
Mr. Yang teaches the Erhu (chinese fiddle)
On the wall hangs a portrait of Mr. Yang
giving himself a pompadour.
(Pre-photoshop, darkroom magic)
Unfortunately. The old man
is retiring, leaving the business
to his ham fisted son.

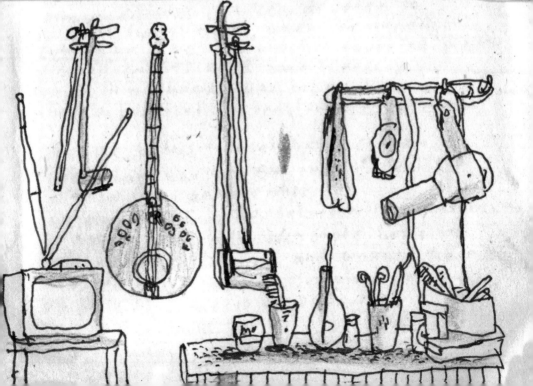

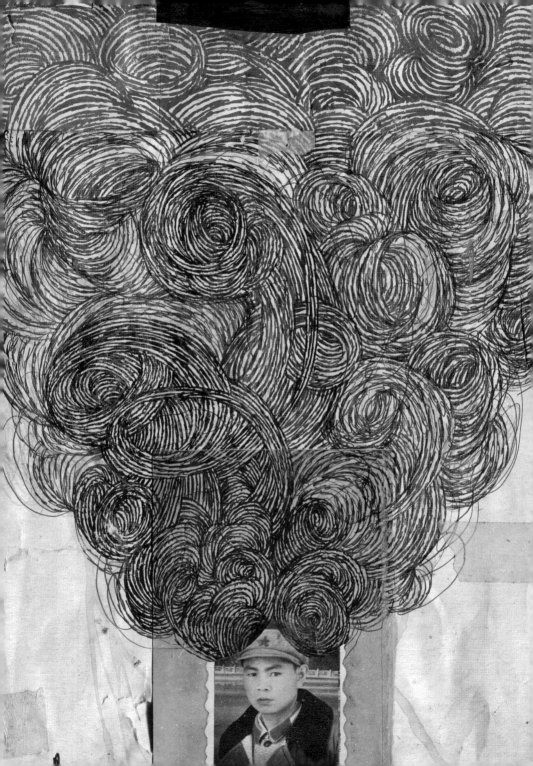

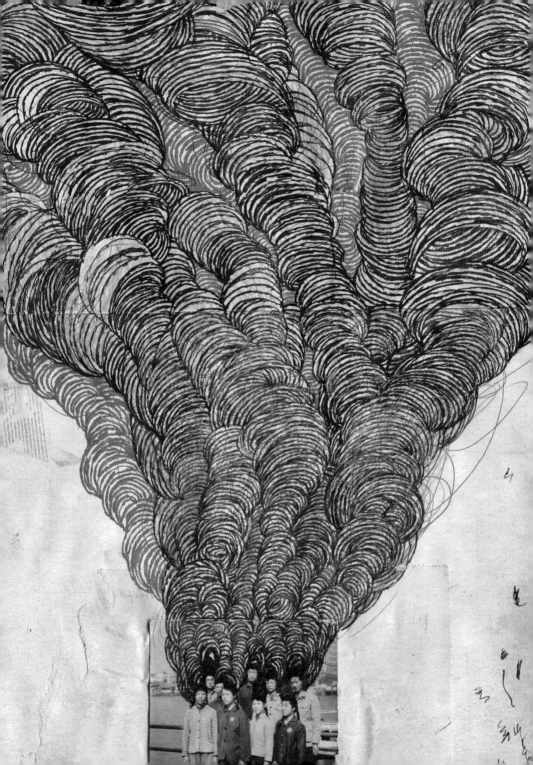

The old town of dali is disappearing fast.
Most of the old buildings have been torn down
(This home is one of The Exceptions).
People pRefer to live in New concrete structures,
they're not damp and they're Roomier Than The old
wooden homes.

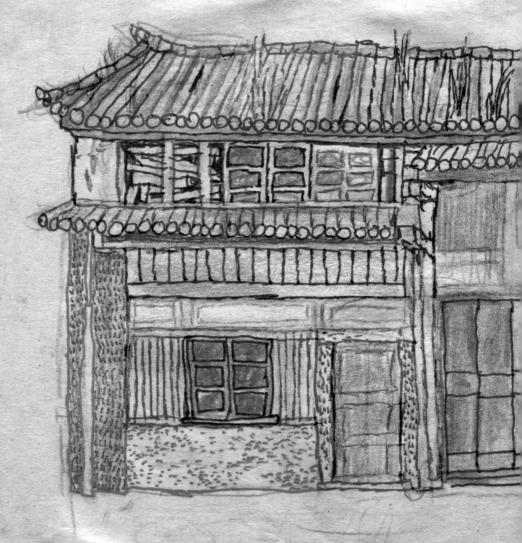

My favorite house in dali, I'm sure
it wont last Long

Even the "Ancient" city wall is New, it was rebuilt in the late '90s. But to tourists this is of no concern, as long as there's a photo-op when they step off the bus.

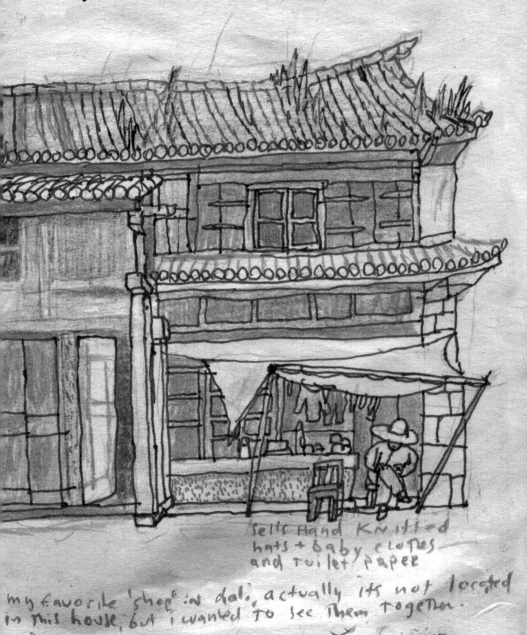

Sells Hand knitted hats + baby clothes and toilet paper

my favorite "shop" in dali, actually its not located in this house, but i wanted to see them together.

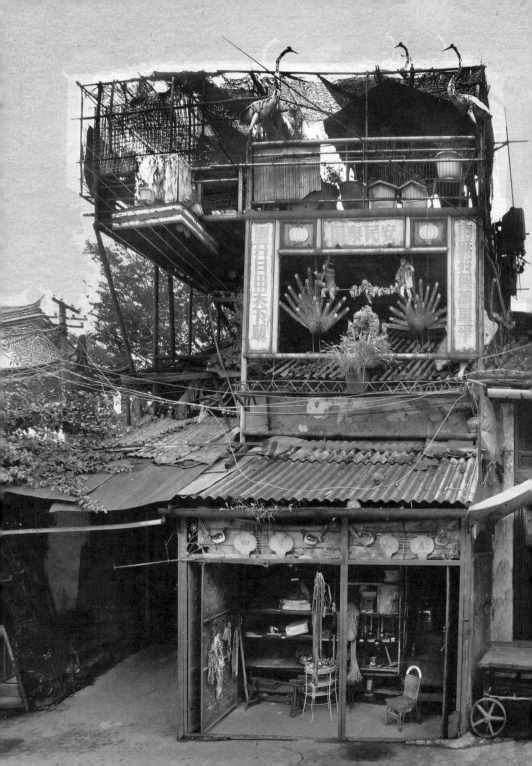

Blacksmith's home and FOLK ART EXPRESSION precariously welded together.

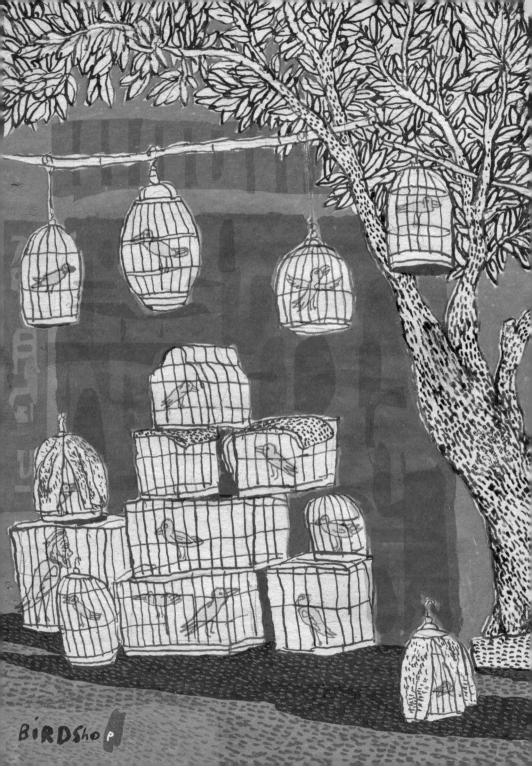

BIRDshop

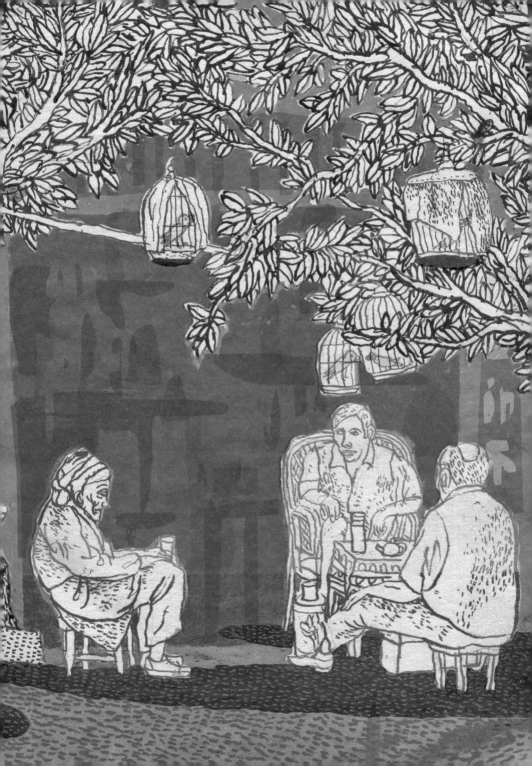

This TRicycle from hell emanates
a ghoulish Vibe i'm not Really sure
what goes on with it, but it's always
seen around Town filled with
The FRESH Skins and Viscera OF slaughteRed cows.

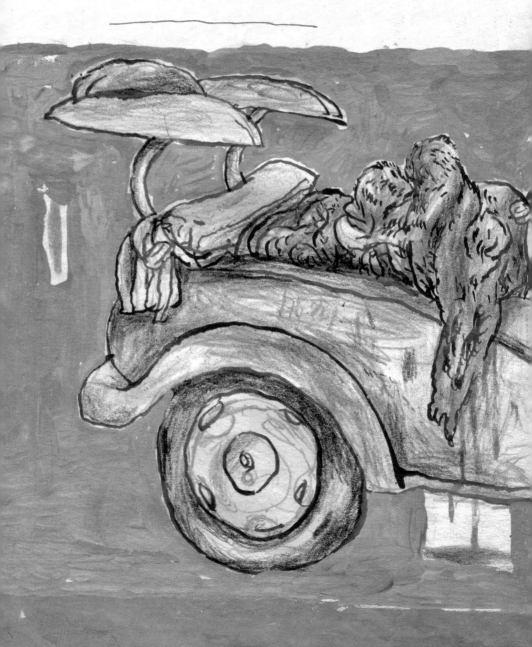

meat scooter

Meat Scooter

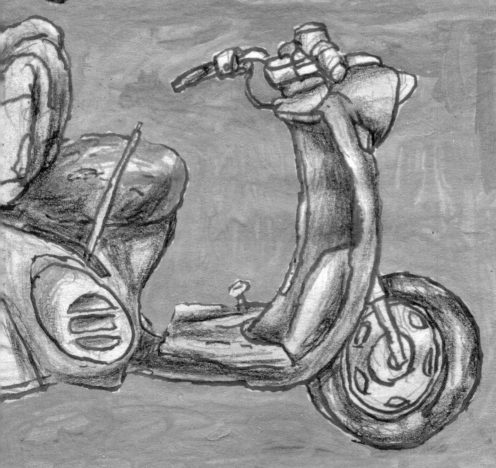

on the rd.

hitchhiking his way from The East coast
to Tibet To visit his cousin.
Possessions: a killer pinstriped suit and
a small ladies hand bag.

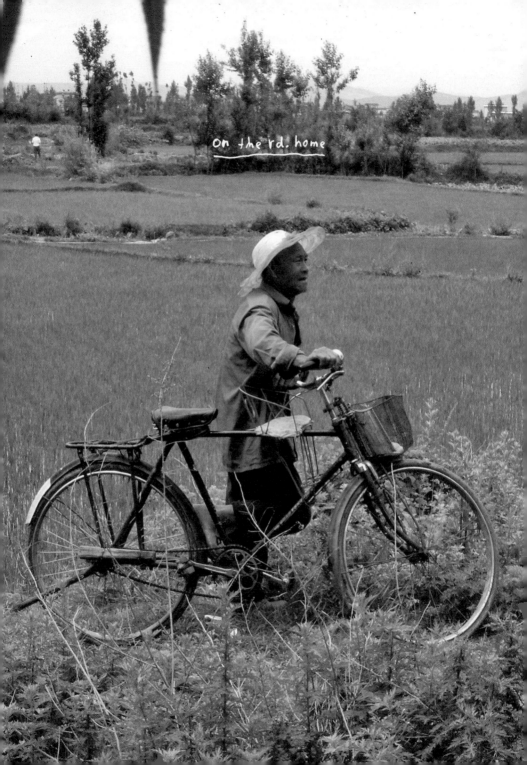
on the rd. home

Safety pin / Pencil seller & Tibetan cowboy

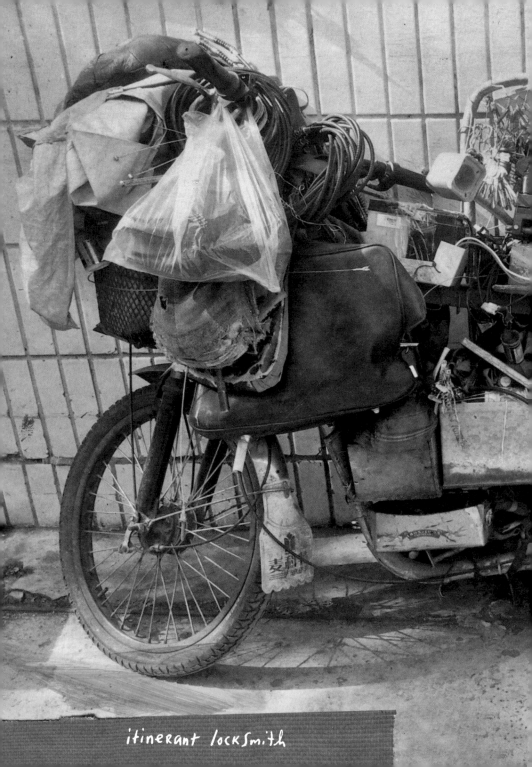

itinerant locksmith

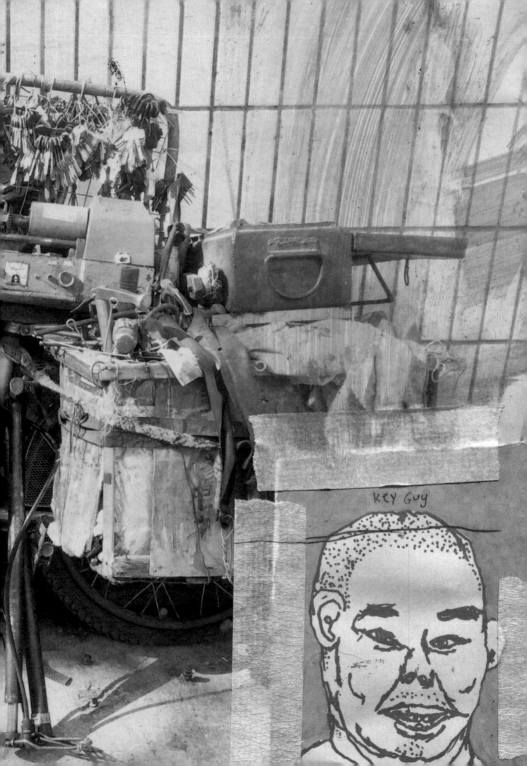

KEY GUY

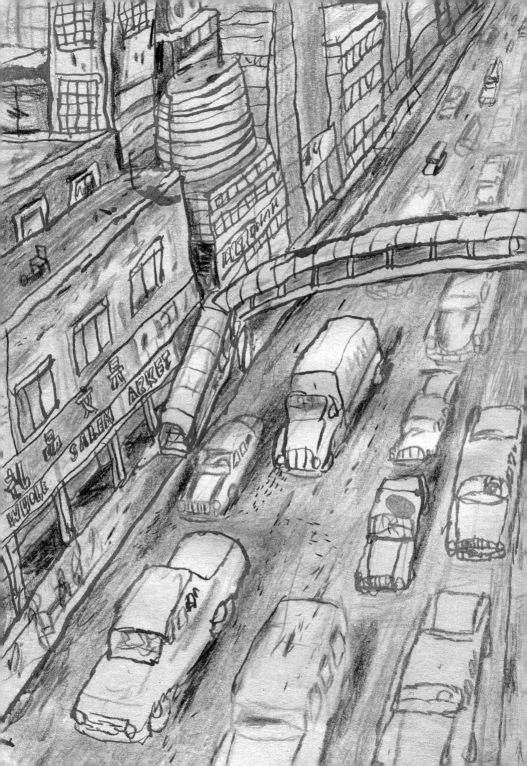

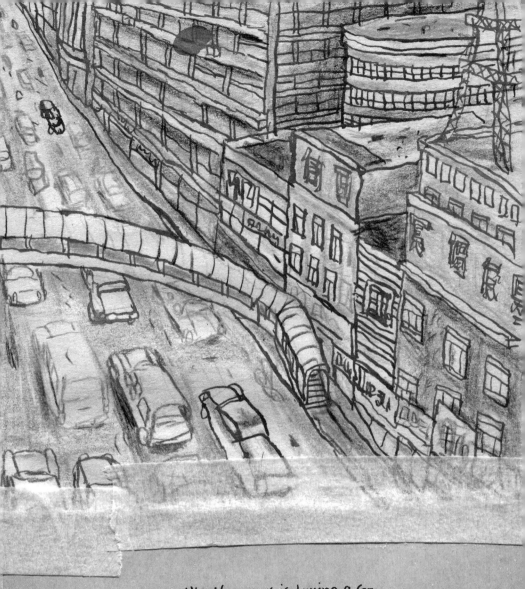

Anyone with the means is buying a car
and hitting The Road.
Cities are sliced up by 8 lane highways
and neighborhoods are being torn down
to accommodate shopping malls the size of Luxembourg.
the remnants of old neighborhoods can still
be found between The highways and malls.
life thrives there; small parks, cozy tea parlors,
and laundry lines hung with socks,
underwear, and drying cabbage.

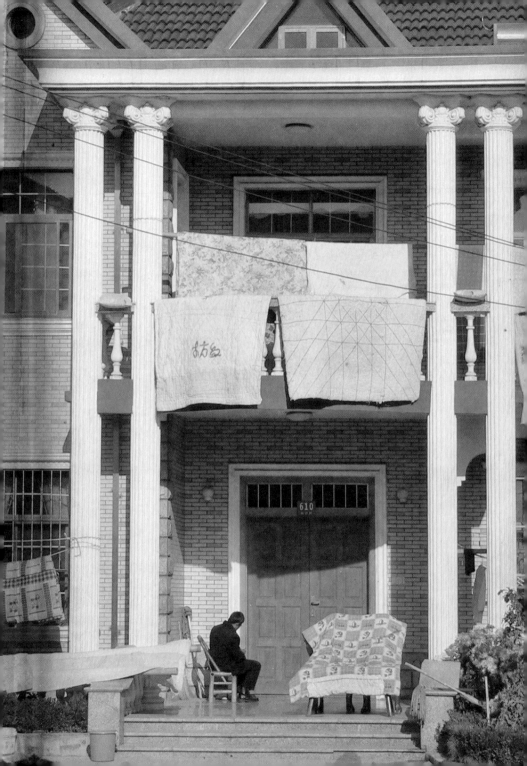

Between Shanghai and Hangzhou
can be seen Row upon Row of McMansions
built by Farmers who hit it big in
manufacturing and Real estate.
most of These appear Empty, Except for
the occasional clothesline strung
between corinthian columns.

unfinished eiffel tower?!

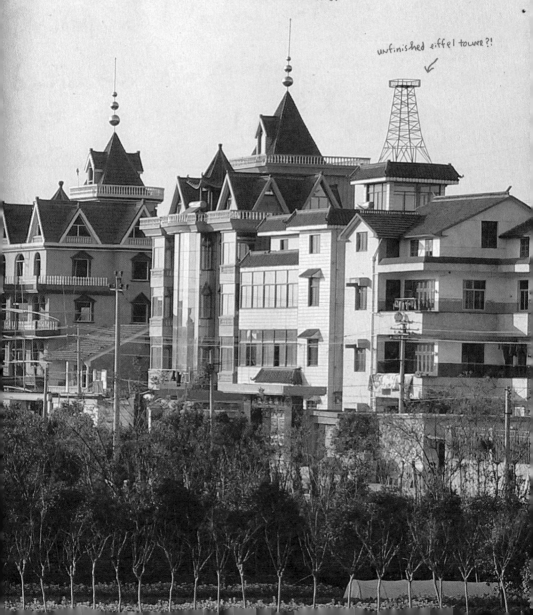

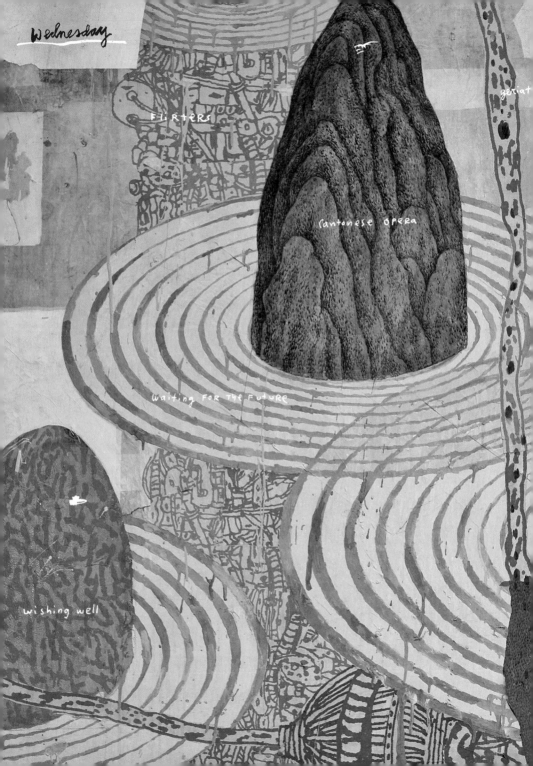

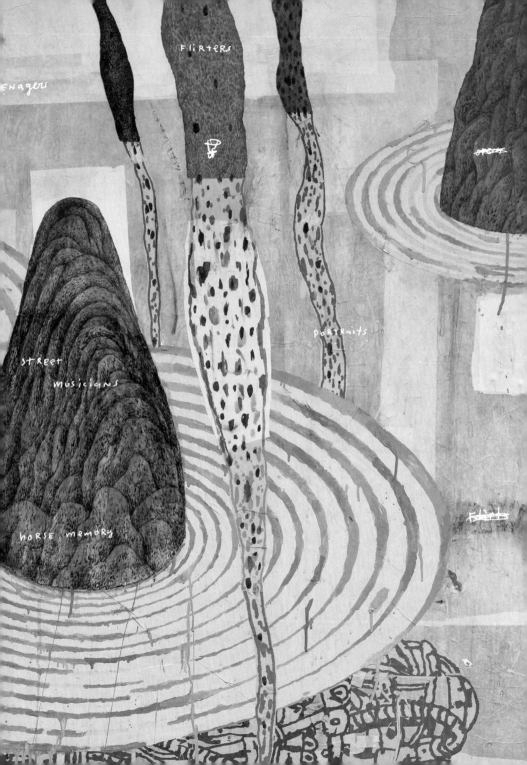

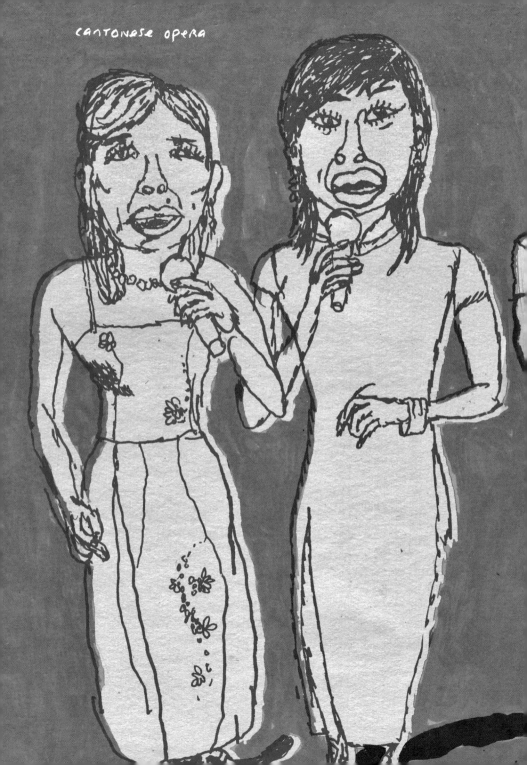

cantonese opera

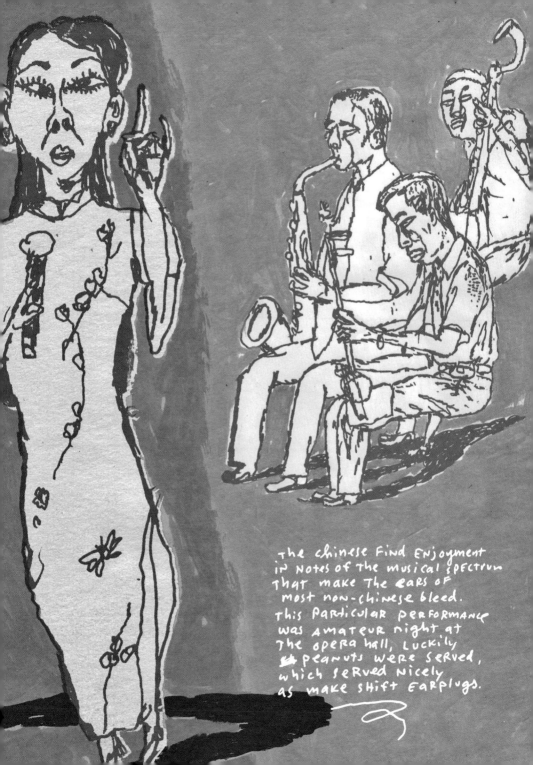

the chinese Find Enjoyment
in Notes of the musical spectrum
that make The ears of
most non-chinese bleed.
This Particular Performance
was Amateur night at
the opera hall, Luckily
peanuts were served,
which served Nicely
as make shift earplugs.

Busking in China is seen more as a beggar's profession than an art form

usually blind musicians will be led by another disabled person.

Flirting Festival

Yao San ling is a Bai Festival of Flirting held once a year north of Dali.
The idea is That young people meet and ~~Extem~~ Spontaneously sing love songs in a Rap like Rhythm To one another.
Trouble is, That all The young suitors are too busy ~~Tex~~ Sexting each other to bother to attend the occasion, leaving The Flirting to The old Folks.

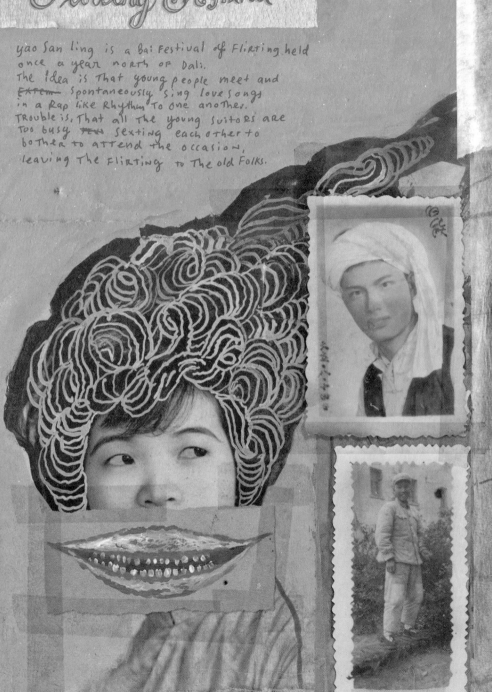

Bai people FLIRT in their own language.

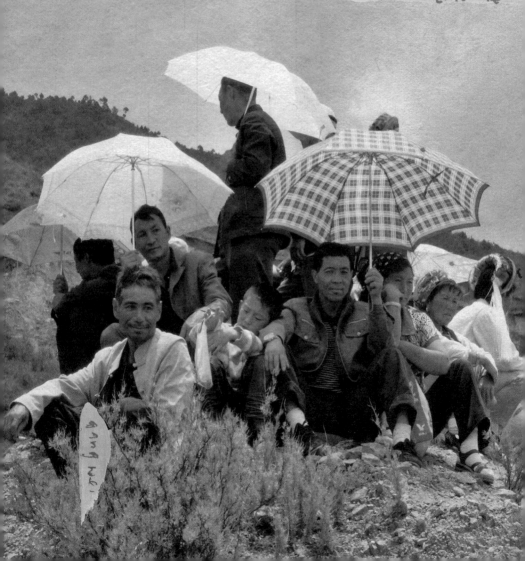

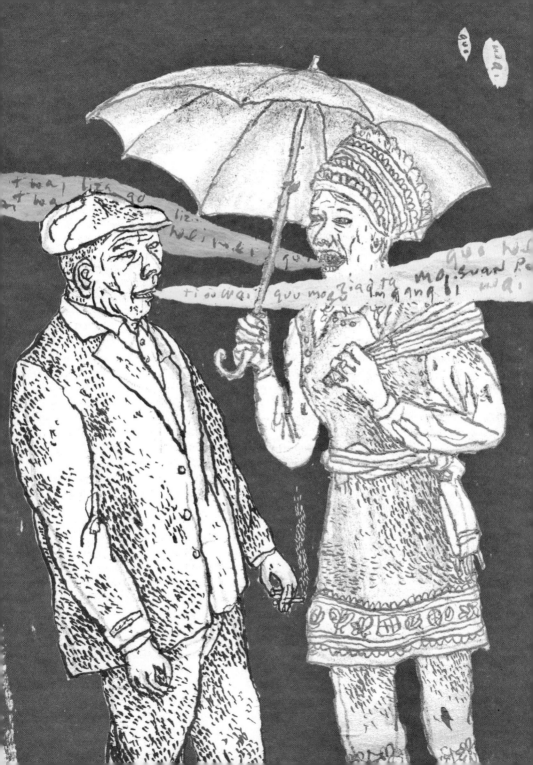

photo-prop
at the Flirting Festival

The HAN ETHNIC group MAKES up AROUND 92%
OF CHINA'S POPULATION.
THE CENTRAL goveRNMENT Relocates large
POPULATIONS OF HAN TO Tibet and Muslim Xinjiang
IN ORDER TO CONTROL THESE Rebellious Regions
by shifting the demographics.

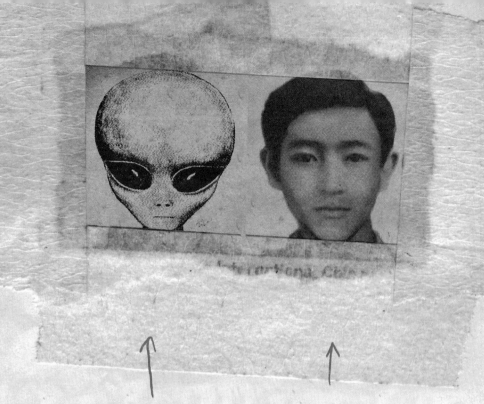

↑ western person's description of their alien abductor

↑ chinese person's description of their Alien abductor

Real

alien

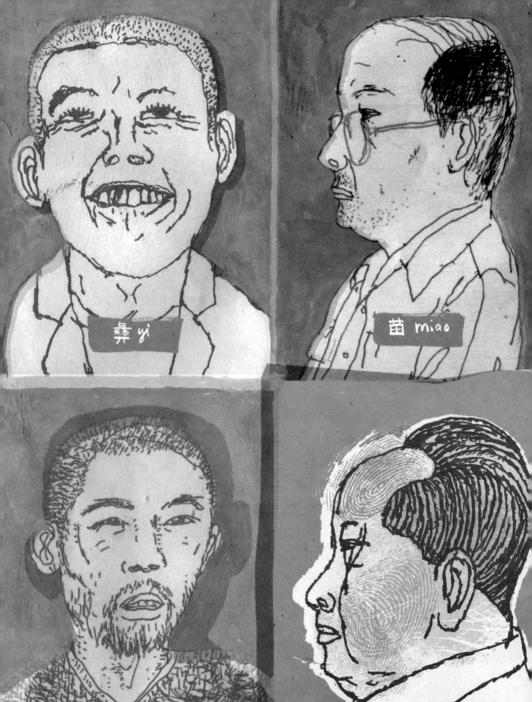

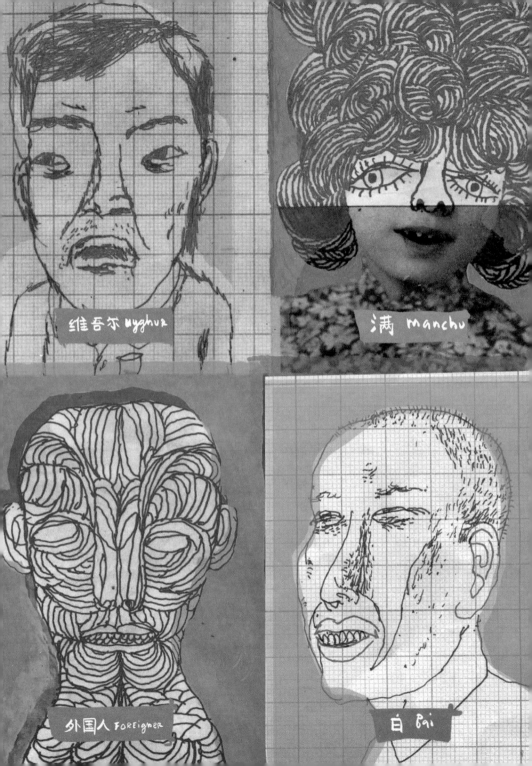

维吾尔 uyghur

满 manchu

外国人 FOREIGNER

白 bai

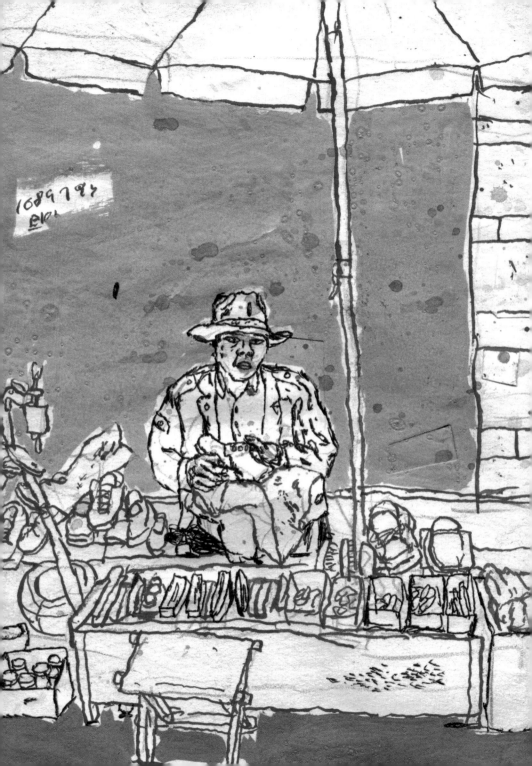

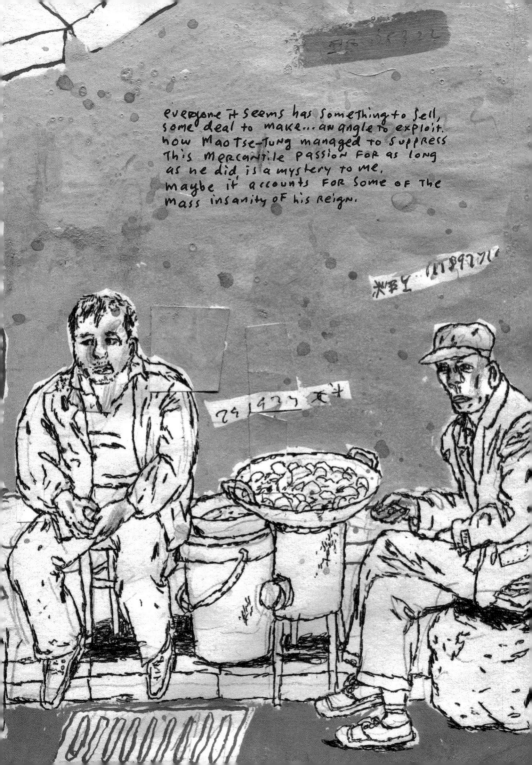

everyone it seems has something to sell,
some deal to make...an angle to exploit.
how Mao Tse-Tung managed to suppress
this mercantile passion for as long
as he did is a mystery to me,
maybe it accounts for some of the
mass insanity of his reign.

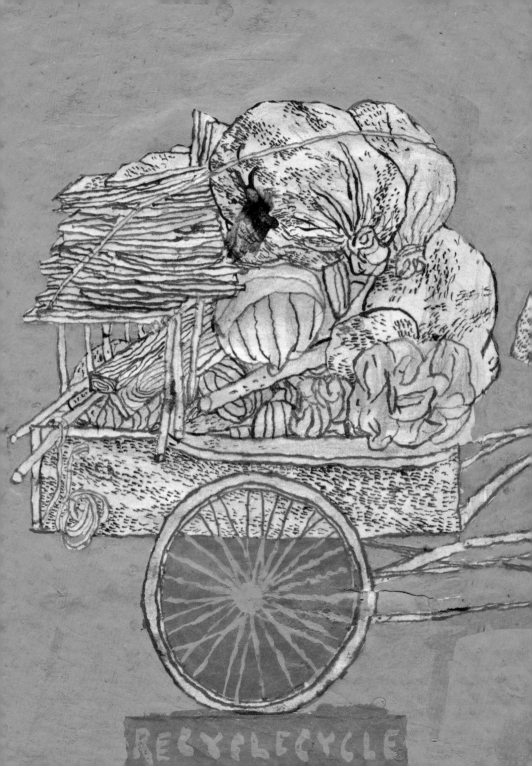

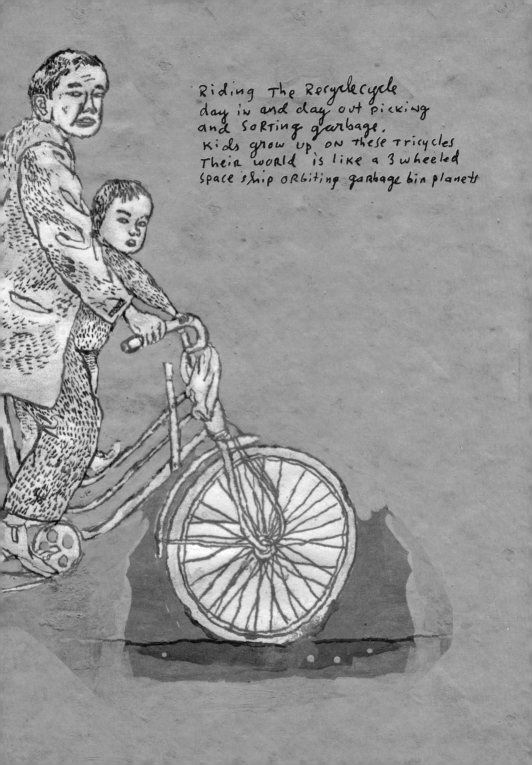

Riding The Recyclecycle
day in and day out picking
and sorting garbage.
Kids grow up on these Tricycles
Their world is like a 3 wheeled
space ship orbiting garbage bin planets

in a floaty place, neither here nor there they sit on their haunches, waiting for future china to reach them.

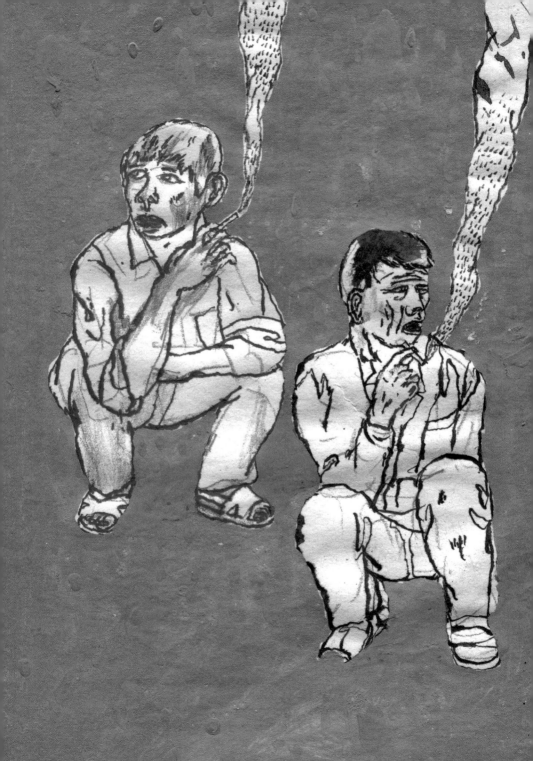

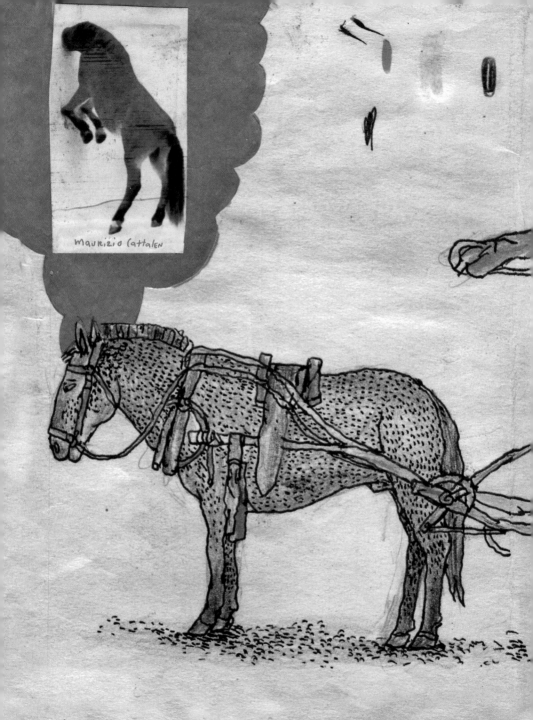

maurizio Cattalen

(dali horse contemplating the direction of contemporary art)

if dali's horses could talk, They'd whinny
Tales of their ancestors' Travels along
The ancient Tea Road, plodding narrow
mountain passes & crossing raging Rivers
on Rope Bridges, Their backs ladened with
cakes of Yunnan's pu-erh Tea, destined
for The lamas and kings of Tibet.

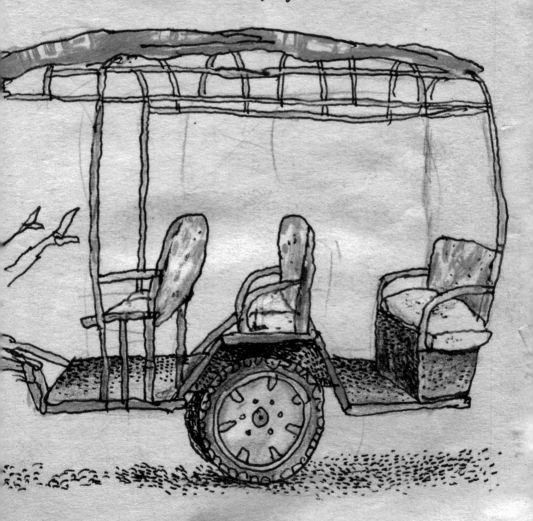

Thursday

MEAT SCOOTER

hot SPRINGS

BIG hair

pushi

burlesque EXTRvaganza

commie consumerism

macao morning

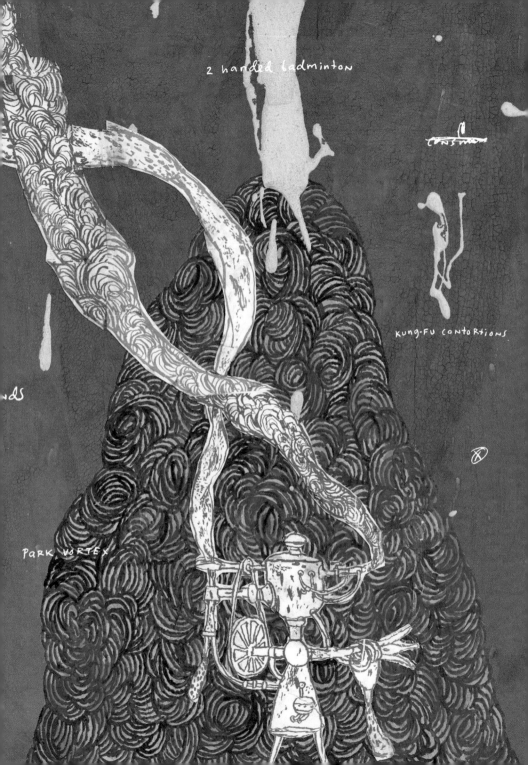

Throughout china, in the early morning, a steady stream
of older folks make their way to the public parks
for activities such as twin racquet badminton playing
(twice the fun, especially while chain smoking)
mah-jong playing, Tai-chi, ballroom dancing and opera singing.
Basically the parks are geriatric playgrounds, compare this
to our sad western custom of warehousing our old folks
in dismal nursing homes and "gated retirement" communities."

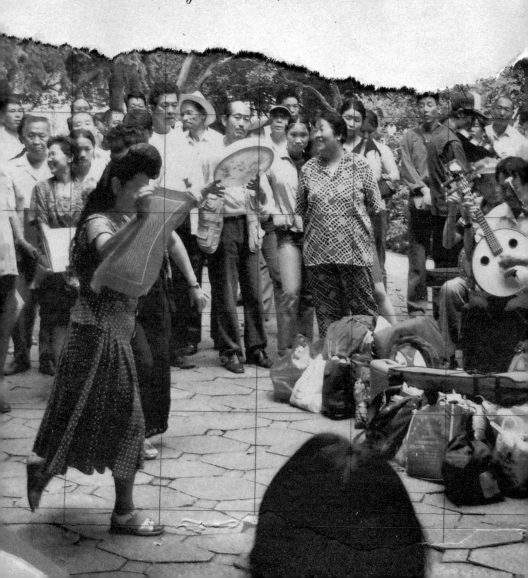

Shanghai Wave

The shanghai wave is a gravity defying hairdo from the '70s + '80s which is still sported by some women of that generation.

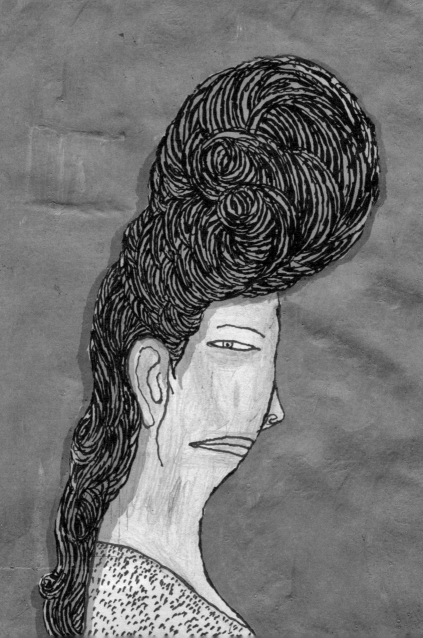

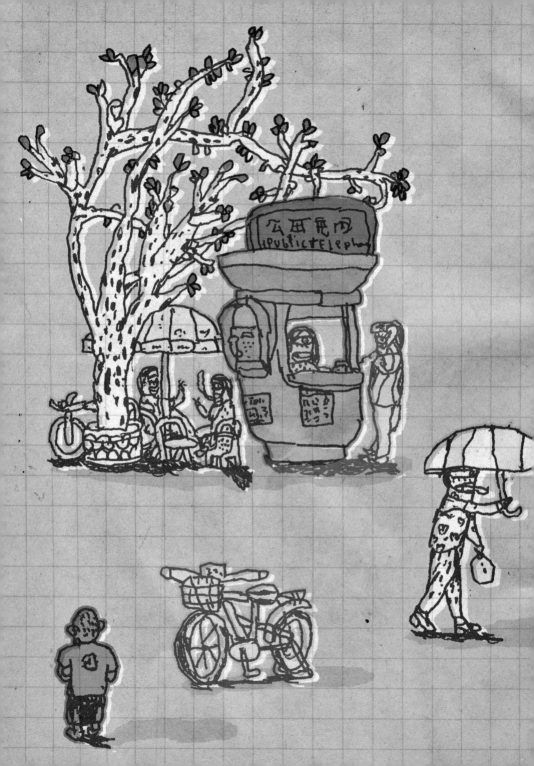

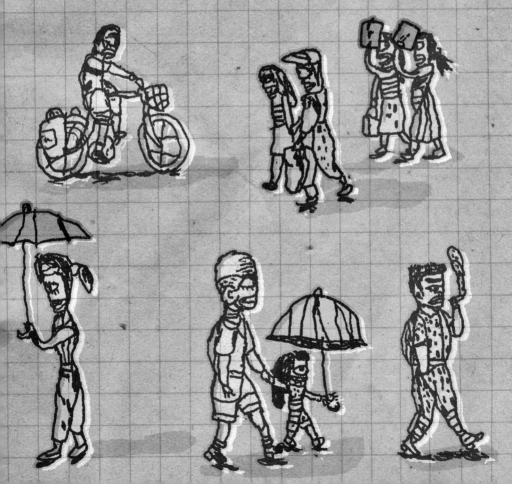

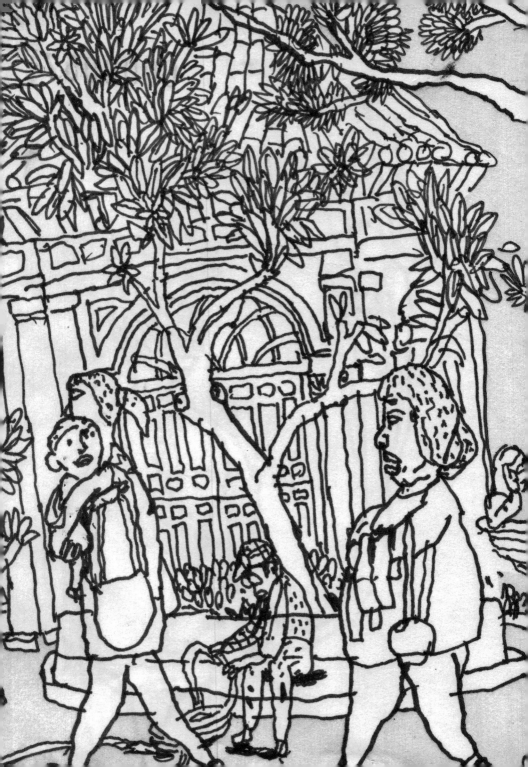

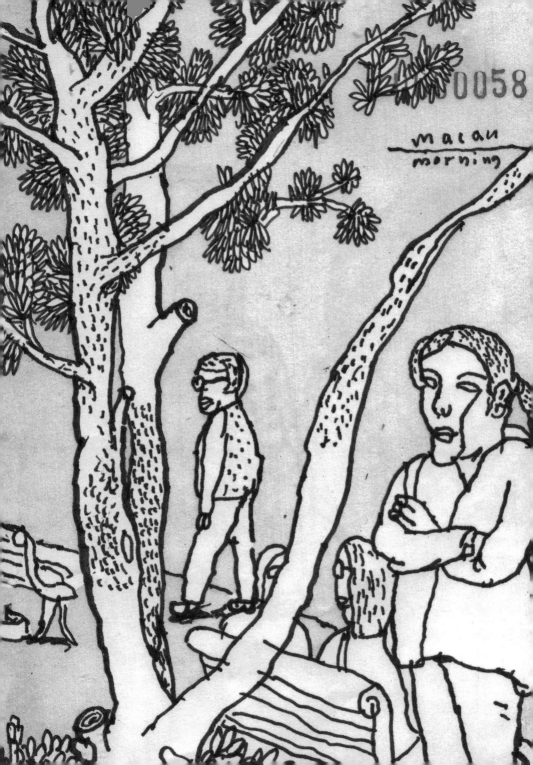

macau
morning

0058

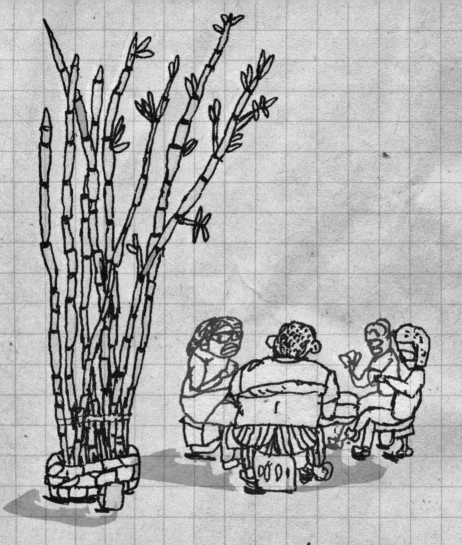

Early, Before The Day's heat descends
like a steamy wet Blanket.
Between bamboo stands
and Badminton COURTS, Next
to a still lake, or under a pagoda.
People claim space to practice
Their morning activities:
playing cards, Pushinghands...
Singing opera to a tree.

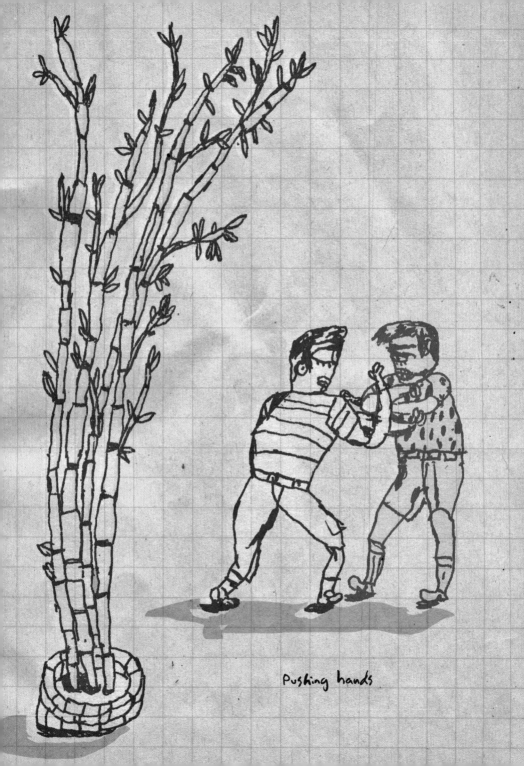

Pushing hands

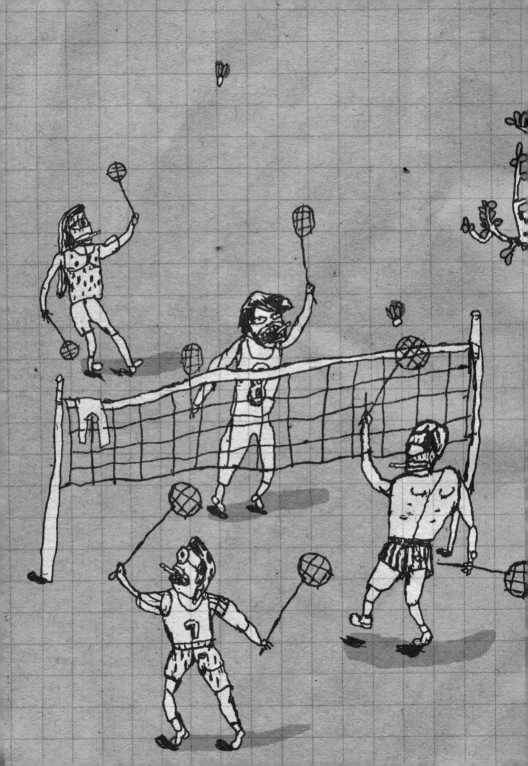

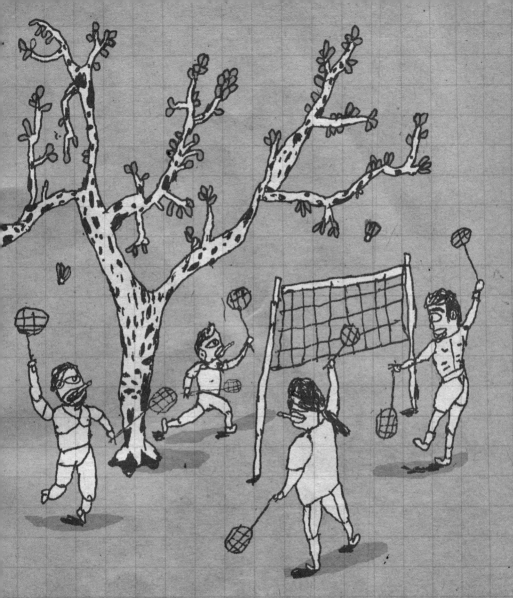

YEAR after year These old friends
have met on The Badminton Court
a Racquet in each hand, a cup of tea
and a cigarette dangling from Their lips
afterwards, many of Them will Head
to The dimsum house together.

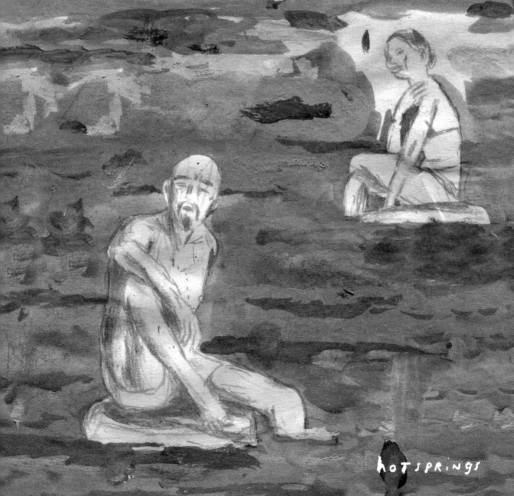

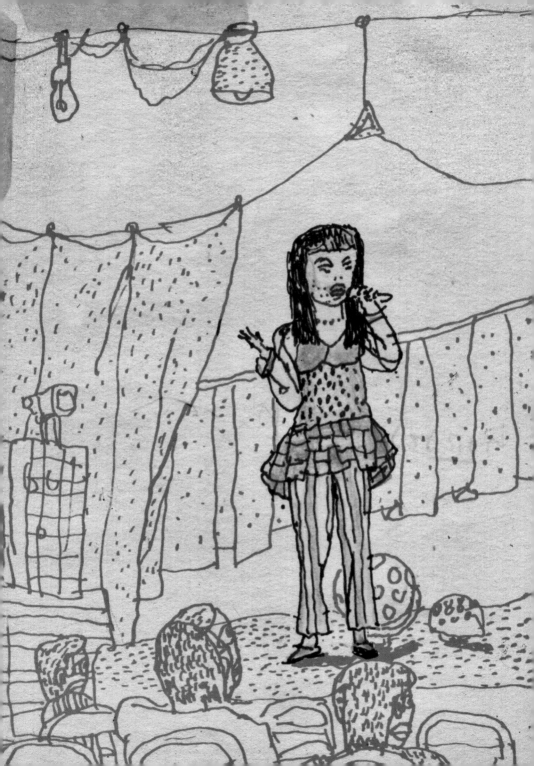

If it's culture one craves, then nearby Xiaguan is the place.

On the fourth floor of a forlorn, half empty office building (the vacant third floor is a free for all urinal) can be found a good old fashioned burlesque theater, complete with transvestite belly dancers, midget sword swallowers and a kungfu master performing death defying escape acts using plastic handcuffs and rubber knives. The shows finale is the revealing of the "world's tiniest woman"

wig

performer

headless Barbie doll

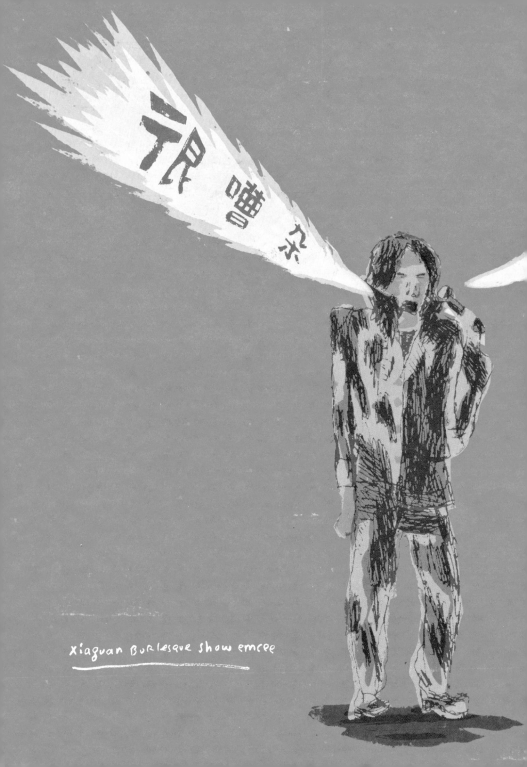

Xiaguan Burlesque show emcee

very LOUD!

dali attracts a motley crowd of
starry eyed hippie kids, spoiled celebrities,
nouveau riche leather clad buddha freaks,
wannabe poets & artists, and other
gangsters, hucksters, and snake oil salesmen,
lending the place an almost
wild west quality.

kung-fu daredevil

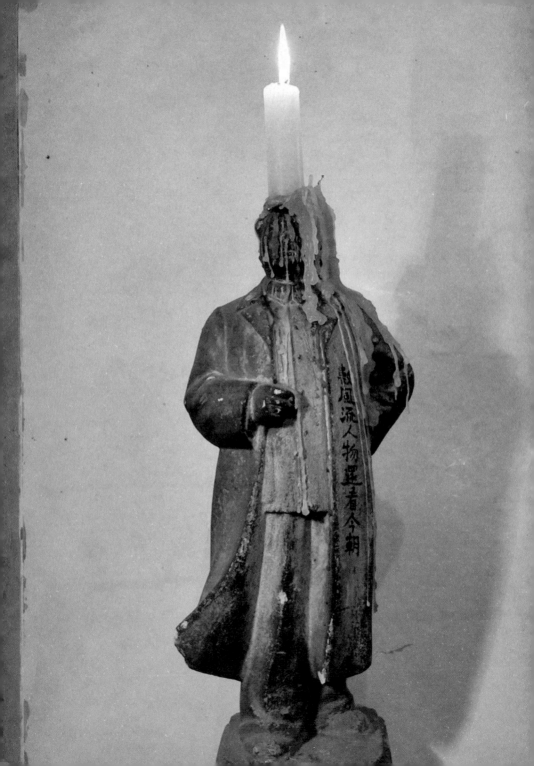

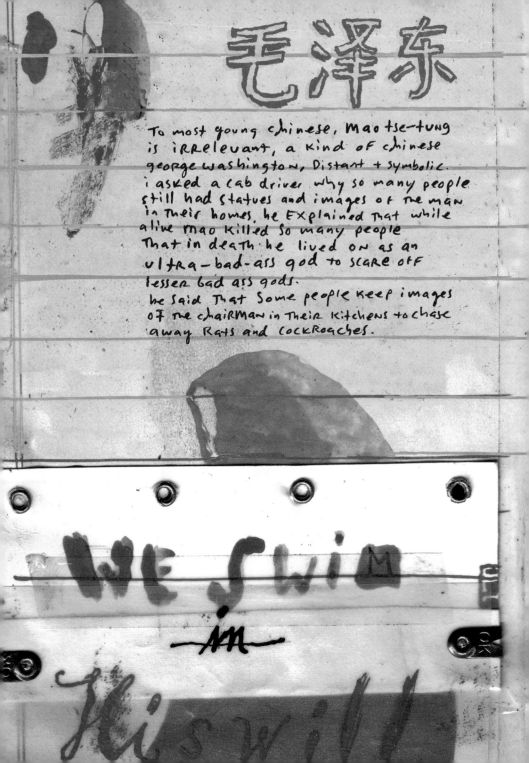

毛泽东

To most young chinese, mao tse-tung
is irrelevant, a kind of chinese
george washington, Distant + symbolic.
i asked a cab driver why so many people
still had statues and images of the man
in their homes. he explained that while
alive mao killed so many people
that in death he lived on as an
ultra-bad-ass god to scare off
lesser bad ass gods.
he said that some people keep images
of the chairman in their kitchens to chase
away rats and cockroaches.

WE SWIM

in

his will

hold the mao

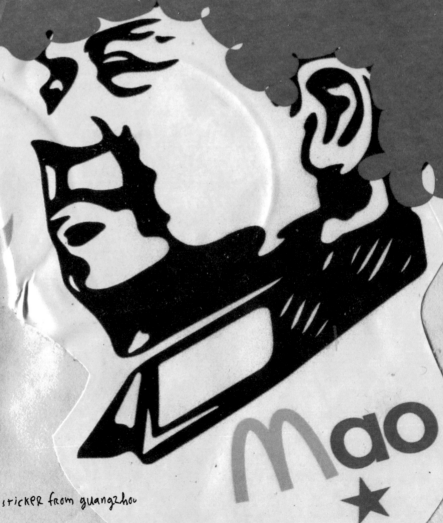

graffiti sticker from guangzhou

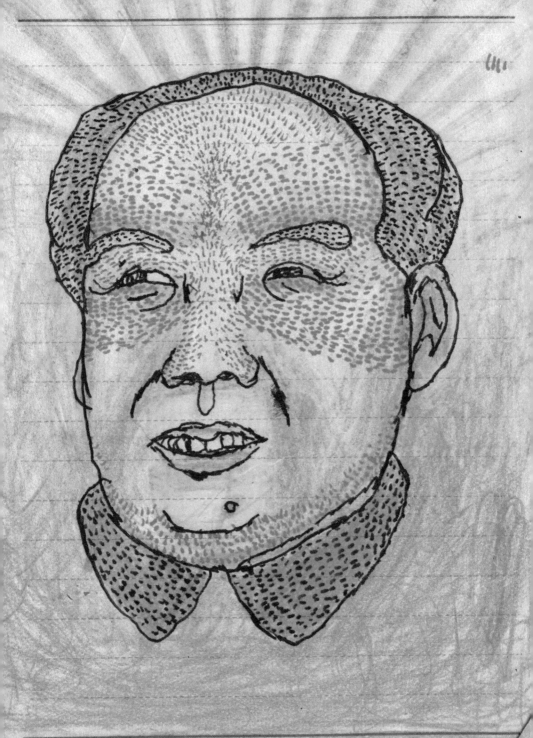

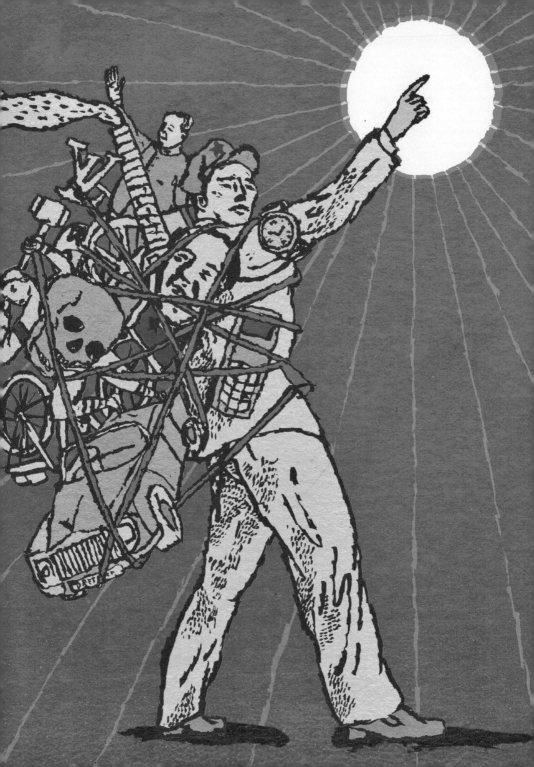

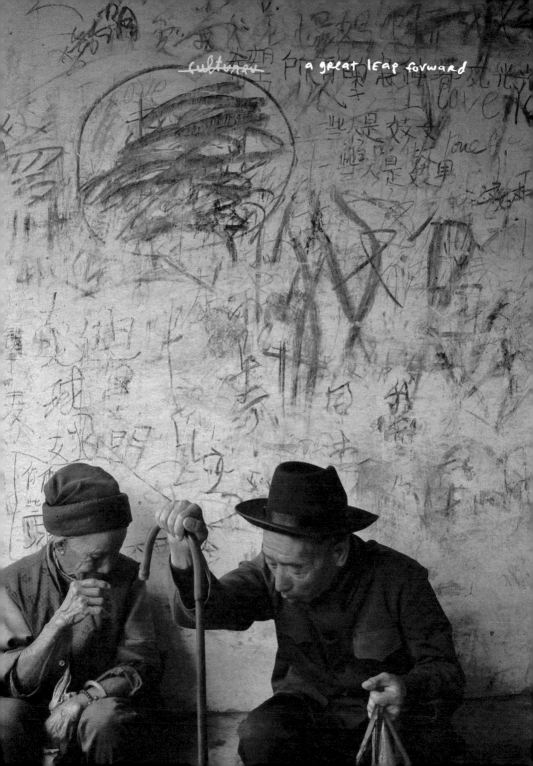

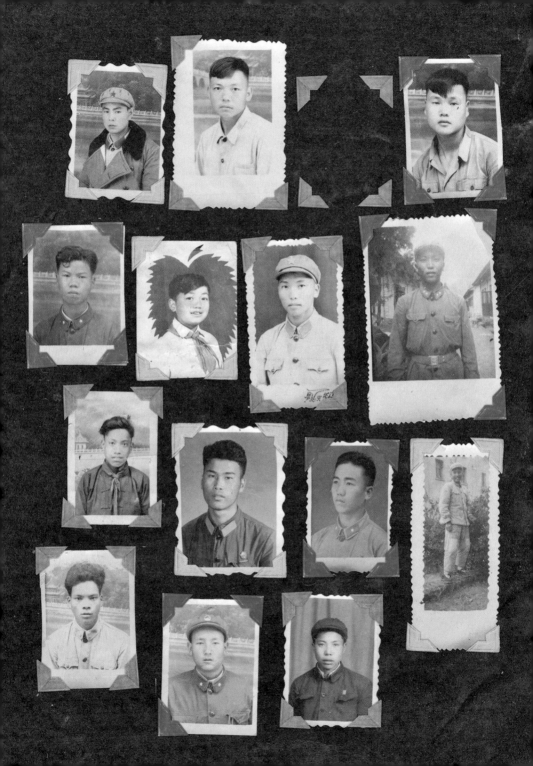

CROWD CONTROL is the operative term in china.
The population clocks in around 1.3 billion souls.
which makes going shopping at the mall on saturday
feel like the stadium crowd leaving a Beatles
reunion concert.
The PARTY spends much of its energy containing
the restless hordes — people are linked to their
place of birth by their identity card (hukou)
which restricts peoples' movements by tying
their work, housing, and education to their hukous.

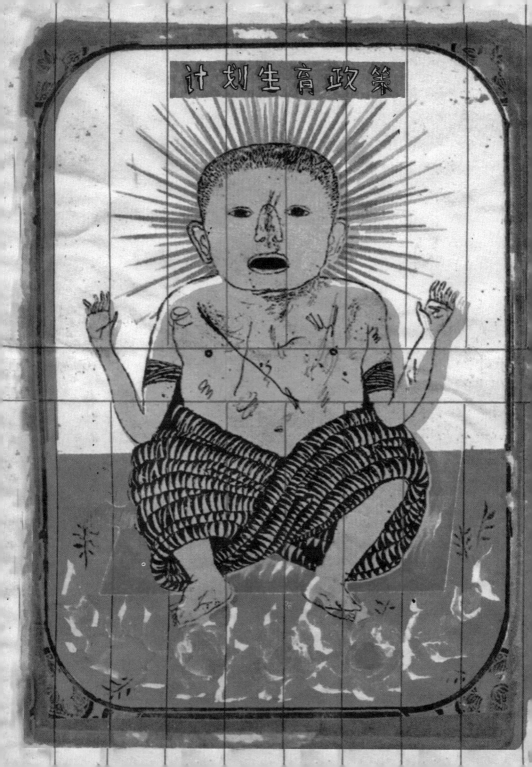

The ONE child policy is another strategy
to contain the masses, originally
instituted in 1979, The program is very
unpopular and has led to the adoption
away of girls (boys are prized).
resulting in a shortage of girls.

having more than one child is penalized with a hefty fine.
once the fine is paid the second (or third e.t.c.)
child gets a hukou (and can be enrolled in school).
leaving the option open only to families of means.

20000020

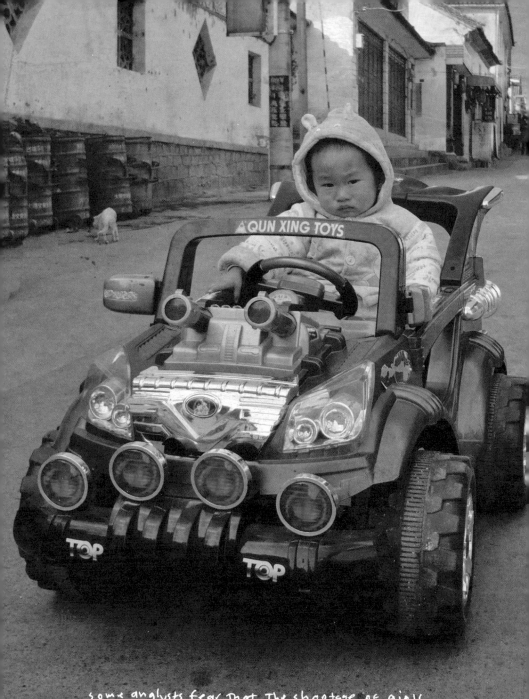

some analysts fear that the shortage of girls
is causing boys out of frustration to become more
agressive and militaristic.

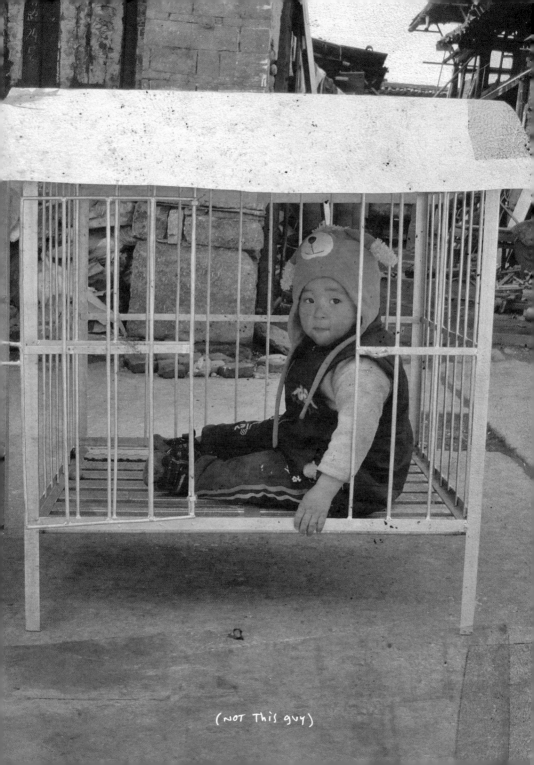

(NOT THIS guy)

204659883

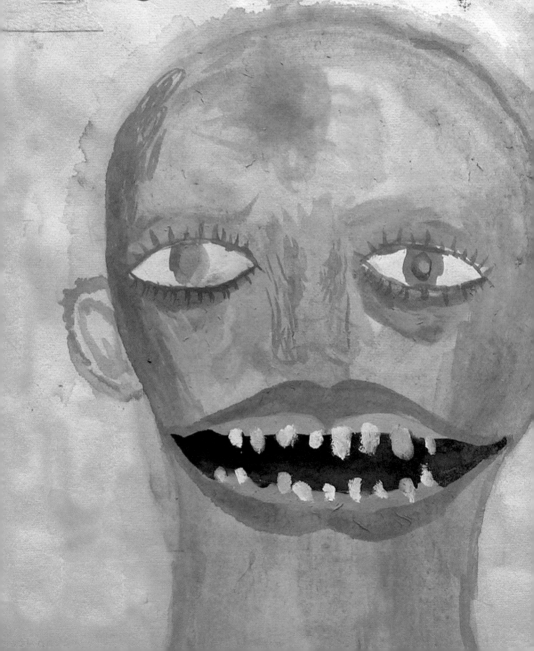

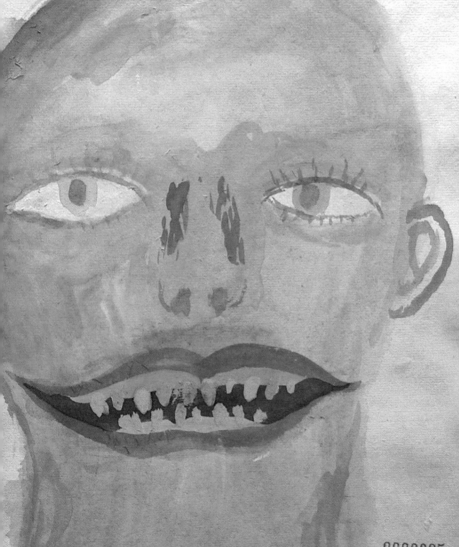

593648772

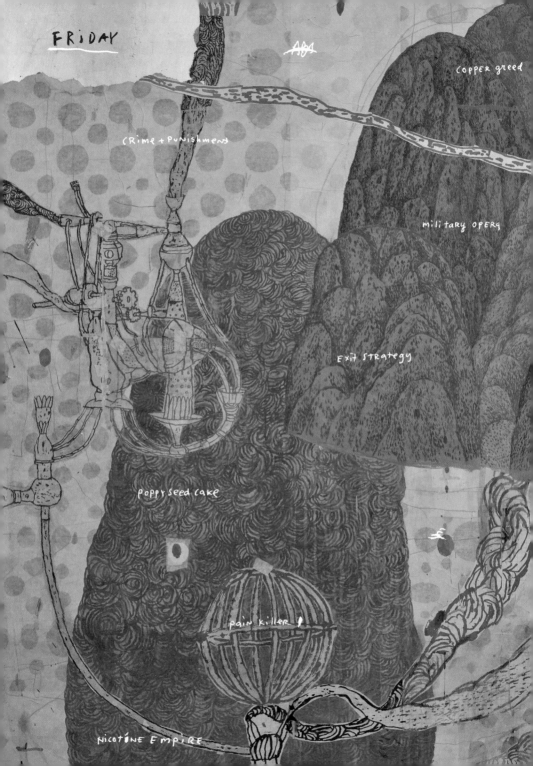

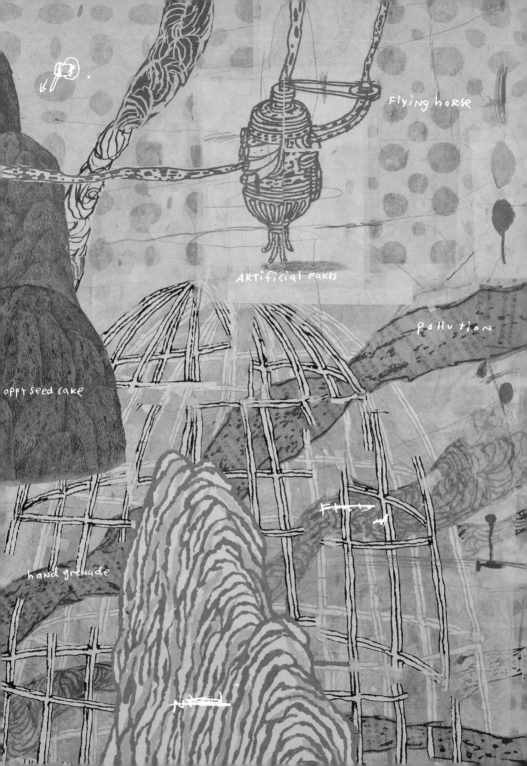

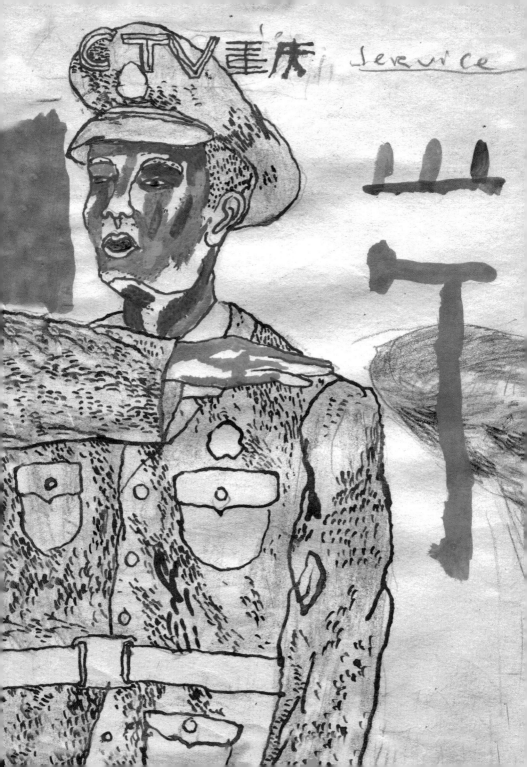

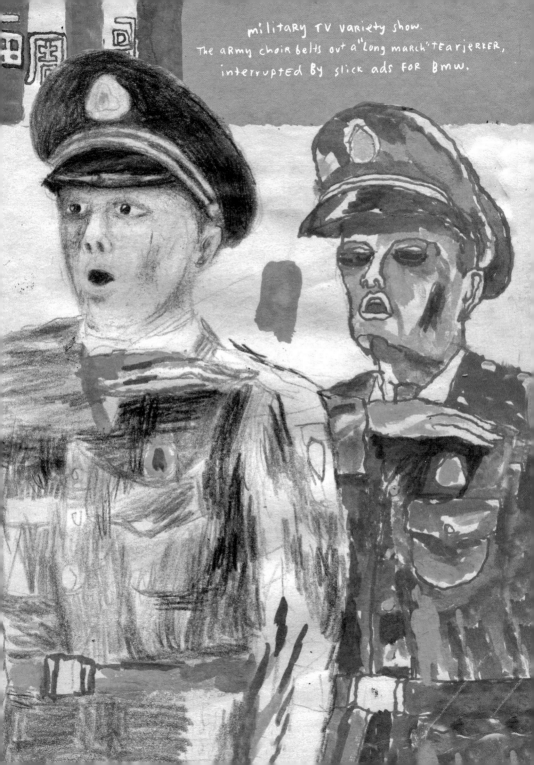

military TV variety show.
The army choir belts out a "long march" TEAR JERKER,
interrupted By slick ads FOR Bmw.

POLICE

严禁盗窃破坏光缆

保护广播
电视光缆线路
人人有责。

● ● ● ● ●
◉

Theft of high tension copper cables
(copper is a semi precious metal)
is a problem in China, For Those who
don't believe that anyone would go to
The Trouble (and Risk) of stealing
high Voltage Cables, consider This;
i Read some years ago about a gang
of thieves who broke into The Construction
site of a New subway station
and made off with Two huge Escalators.

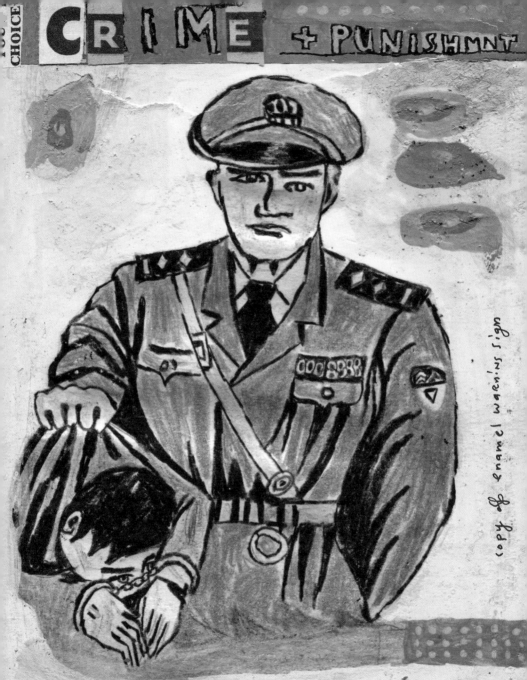

CRIME + PUNISHMNT

copy of enamel warning sign

THERES A PRICE TO PAY IF YOU STEAL
PUBLIC ELECTRIC CABLES !!

POPPY TEARS

牙乌片

SLICE OF CROW

अहिफेन

McCormick
100% Organic

POPPY
SEED

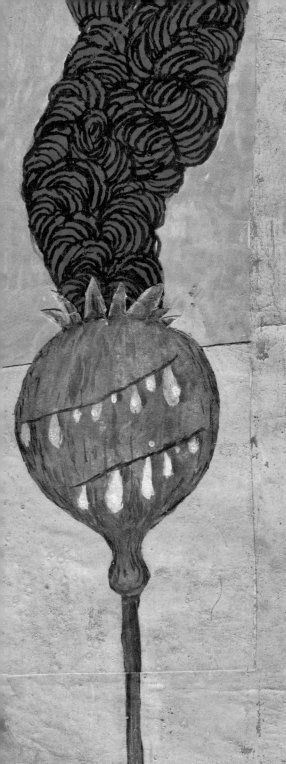

To aid the war on drugs, poppy seeds are banned, leaving us to smuggle the nefarious seeds from Hong Kong otherwise we'd have to quit poppy seed cake cold turkey.

感冒止痛散

PAIN KILLER

假的
FAKE-O

cherished notions of authenticity & product integrity
quickly evaporate when visiting china.
Louis Vuitton and Armani labels are sold by
the yard in fabric markets across china.
Some other popular faked items include:

<u>Wine:</u> wine drinking has opened a booming
market in china for counterfeit varieties,
usually if a wines label is too FANCY i.e.
too much gold embossing, free cork screw e.t.c.
and/or dodgy use of the English language
it's a good sign that the contents were
created in a laboratory, not a vineyard.

<u>Cooking oil</u>: Sometimes referred to as
"GUTTER OIL" the waste oil from restaurants
and believe it or not from the surface of
sewers and drains evaporated off, — "REFINED"
and resold again to restaurants.

<u>iPhones:</u> They look the same but everything
is fake about them... they even have "improved"
iphones, smaller or bigger... with larger speakers,
flash lights etc.

<u>Soy sauce:</u> this fake sauce is commonly used
in restaurants to save money, it is basically
colored, salted water.

<u>goat meat:</u> b.b.q. stands are notorious for
using dogmeat instead of the more
expensive goat.

<u>Eggs</u>: yes, eggs!! they're carefully prepared
using chemicals, complete with "shells," white
and yolk.

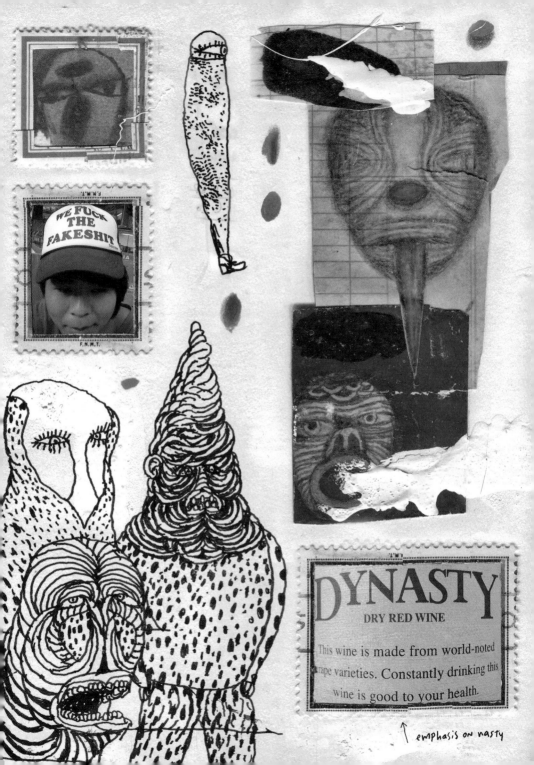

we westerners are outraged at
china's pollution, and worker exploitation
forgetting of course that these problems are
largely a by-product of manufacturing dirt cheap stuff
for us to buy in the walmarts and costcos
across the land of the free and the brave.

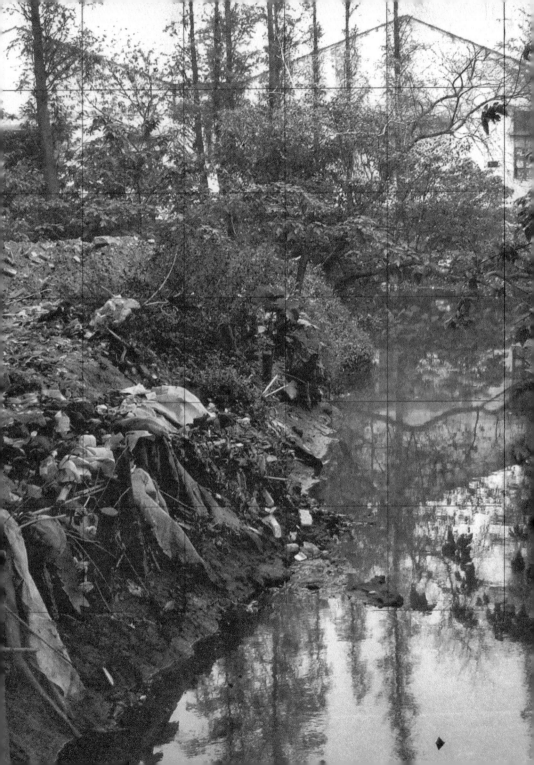

Cigarettes are offered as (and) trays at weddings and (appropriately) funerals

China Tobacco Company is government owned

Prices range from ¥.50 per pack

to over ¥100 for special "guanxi" coffin nails

many men in china smoke cigarettes

which accounts for all the spitting

SUPERIOR DESIGN · EXCELLENT TASTE

pure flavor · elegant fragrance
joining hands to create a
ruby like brilliant life

Virginia Type

HONGHE

HONGHE CIGARETTE FACTORY, YUNNAN

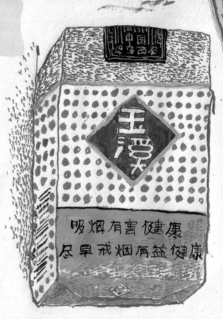

吸烟有害健康
尽早戒烟有益健康

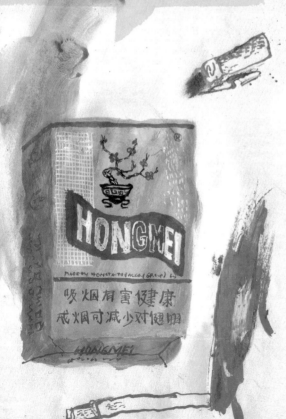

HONGMEI

吸烟有害健康
戒烟可减少对健康

DA XIA MEN

PANDA

Hong.He

Hongmei

The ruby like brilliant life

太空人

many, if they can afford it, send their kids overseas to get educated, sometimes one of the parents (usually the mother) will follow to take care of the child, and to establish a base as a contingency plan, if and when shit hits the fan back home. These people are called "Tai kong ren" — astronauts ... because they're exploring "outer space." Recently there was a post online listing government officials who hold foreign passports + visas. as well as homes and large investments in foreign countries.

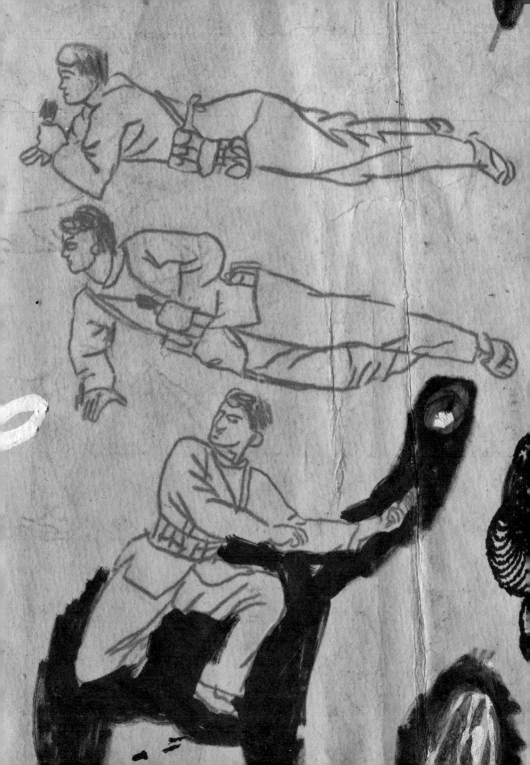

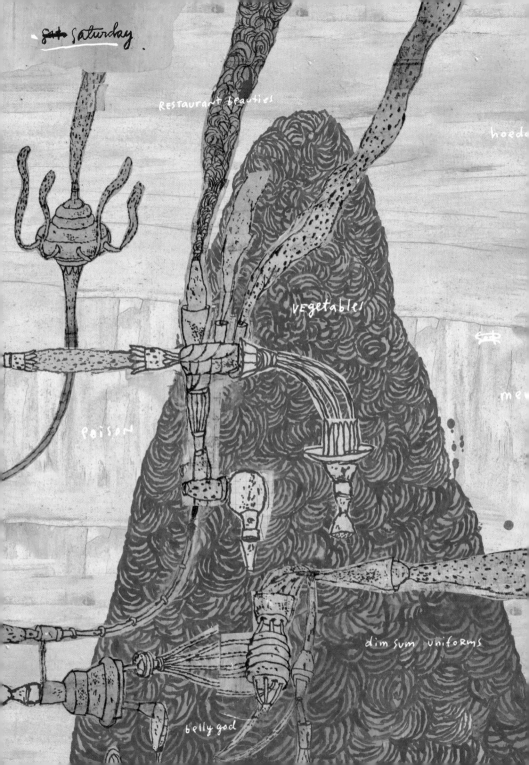

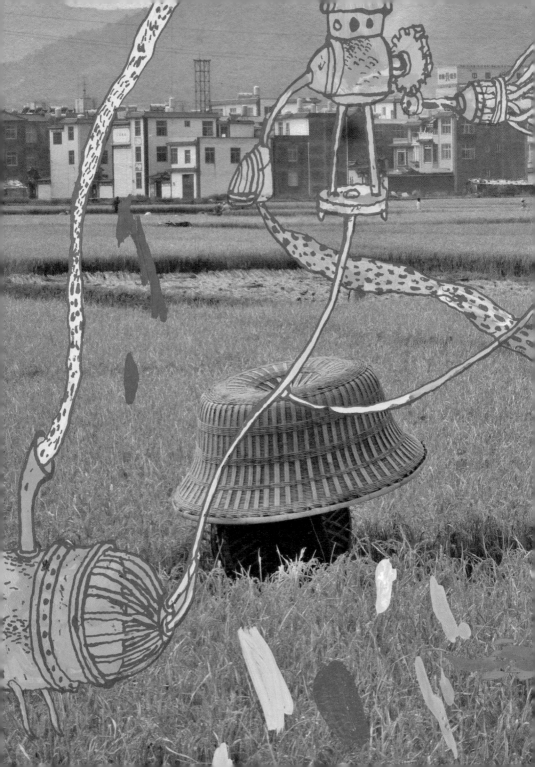

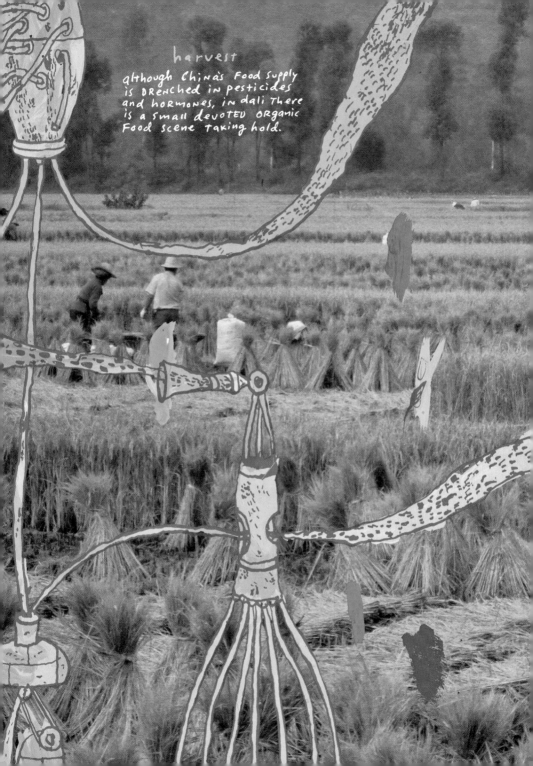

harvest

although China's Food Supply
is DRenched in pesticides
and hormones, in dali There
is a Small devoted organic
Food scene Taking hold.

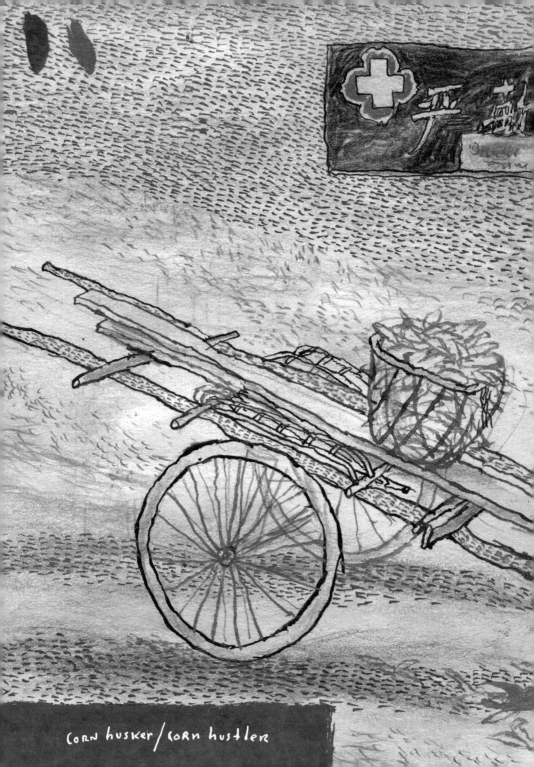

corn husker / corn hustler

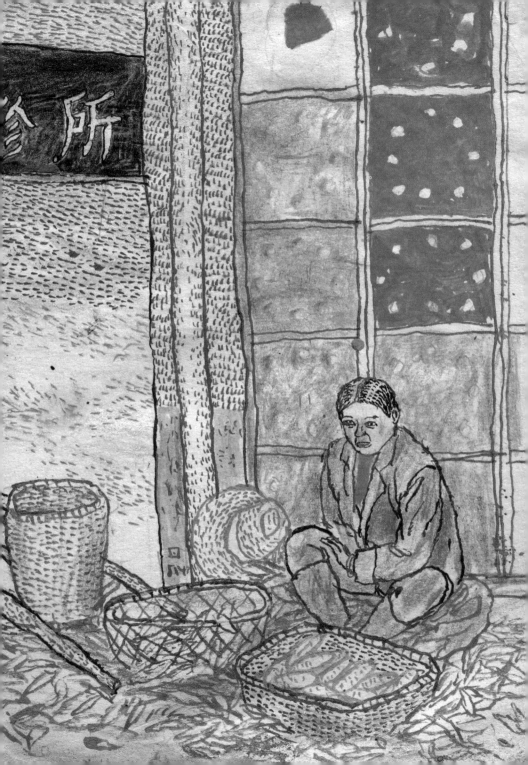

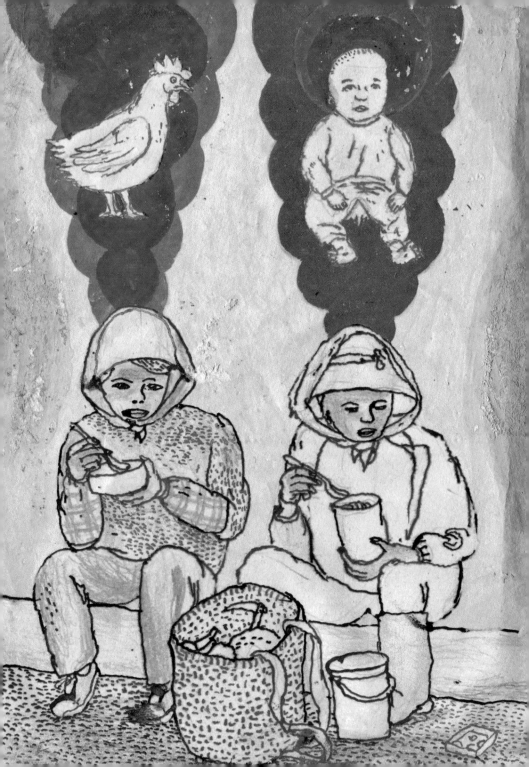

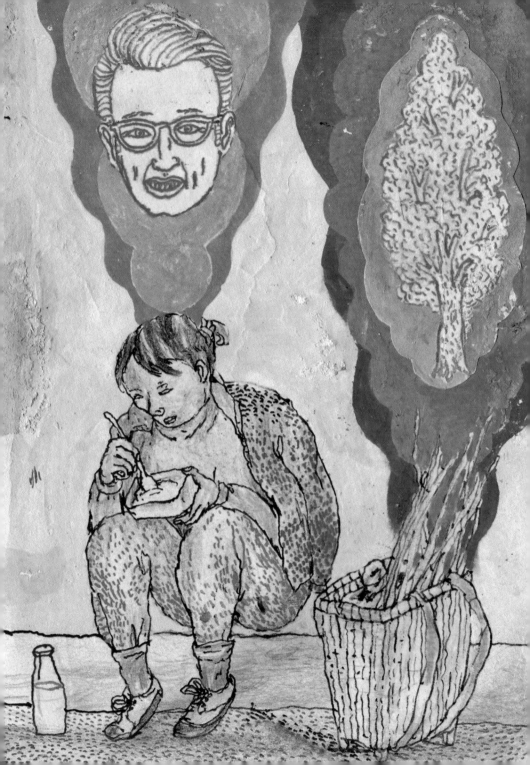

Food varies from region to region...
actually it varies from village to village, but to
generalize recklessly it can be said that cantonese
cuisine is mild and fresh. Shanghai food
can be slightly sweet, in the north rice is
replaced with buns and dumplings.
In Sichuan the food is rich, oily, and spicy.
Which is also the case in Yunnan, but less so.
Out west in Xinjiang the dishes
begin to have an arabic slant, using
star anise and cinnamon and it is eaten with
flat bread instead of rice.

(below a crazy menu compilation from my travels)

家常菜式
Family-style dishes

金珠玉腰闹霸王 Overlord with golden pearl and jade waist	128元
毛家土肉 local meat from Mao family	28元
金豆带皮蛇 Golden Bean of snake with snake-skin	88元/斤
蟹粉鱼唇 stewed fish-lips with crab meat	58元
霸王肘子 Chili pig s front leg	48元
虫草炖老鸭 stewed old duck with insect-grass	22元
蟹粉狮子头 rich's head with crab meat	118元
尖椒炒腊猪鼻 cured pig-nose meat with hot pepper	28元
炒猪血丸子 Fried pig blood curd ball	28元
红烧狗肉体 dog's meat stewed in soy sauce	58元

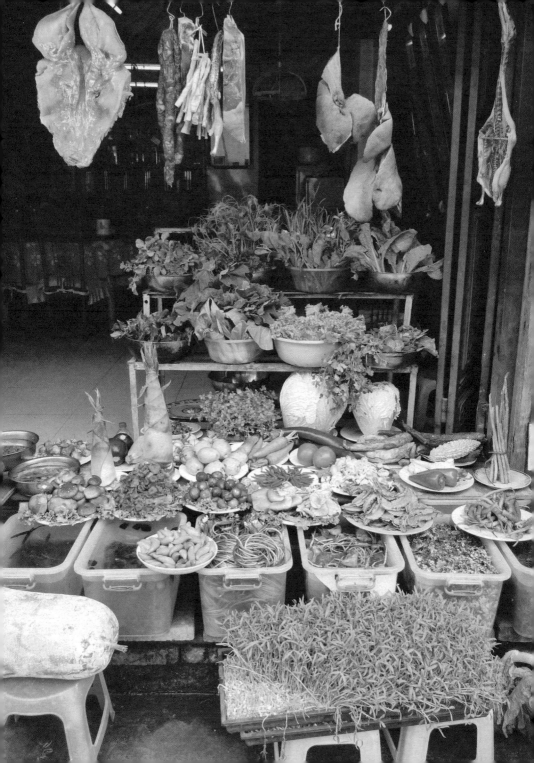

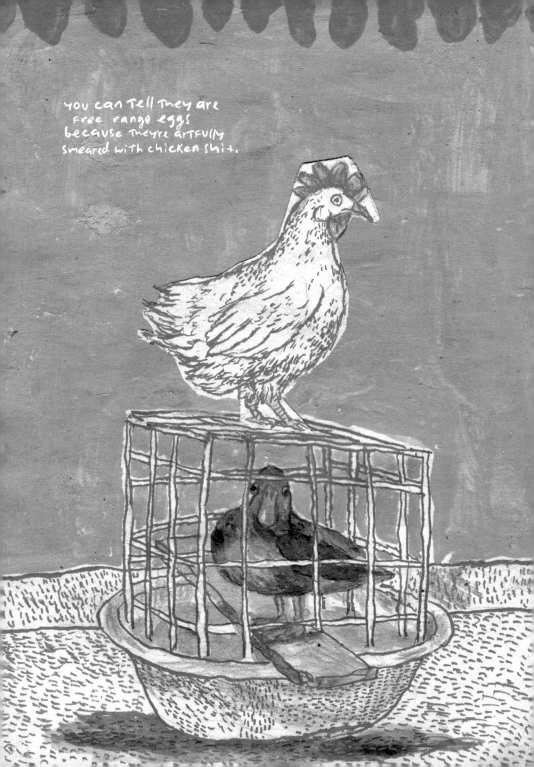

鷄蛋 Tu ji dan FREE RANGE EGGS

Some Restaurant seat 3000
and still there can be a wait

like The FRENCH, People in china
Really KNOW their Food,
Eating out has an almost jaded
Feeling to it. compliments to
The chef are PRActically UNHEARD OF.
THERE is an EXPECTATION THAT
The ingredients ARE FRESH,
and THAT the dishes are
PREPARED "correctly". if these
CRITERIA ARE met, Then EVERYTHING
is "Keyi" (o.K.).

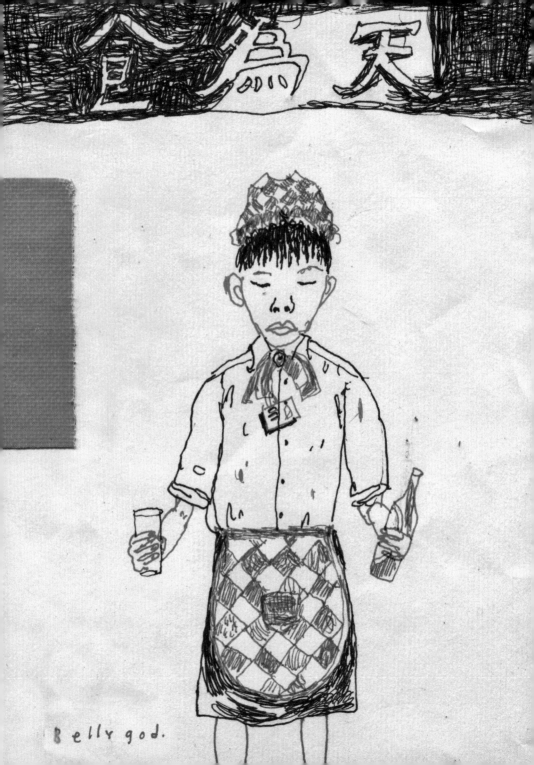

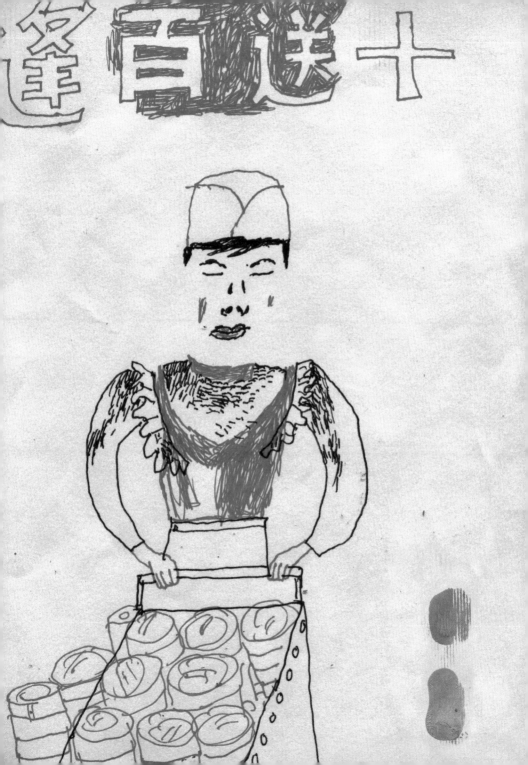

196028 02825
Awen
亞文

soeuast

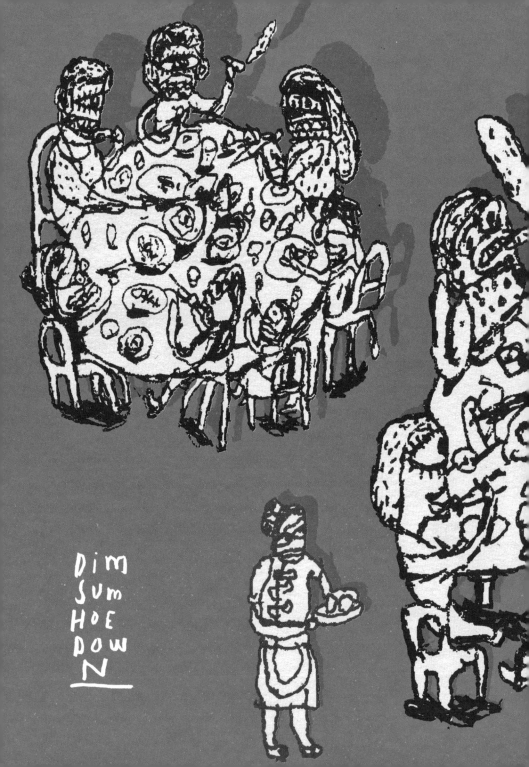

DIM
SUM
HOE
DOW
N

inEDiBLE poochesꓸ

Dali Dogs are a breed apart from
your average domesticated lab or Collie.
They're smaller & compact, ugly and can be vicious,
they're usually in Dire need of BRAces and/or a muzzle.

one of the reasons small rat—like dogs
are favored over larger handsome couch hogs,
is that The big ones are more appetizing Roasted,
and therefore often stolen.
i was told by a friend, a connoisseur of
Dog dishes That There is a hierarchy of
dog delectability which goes something
like This:

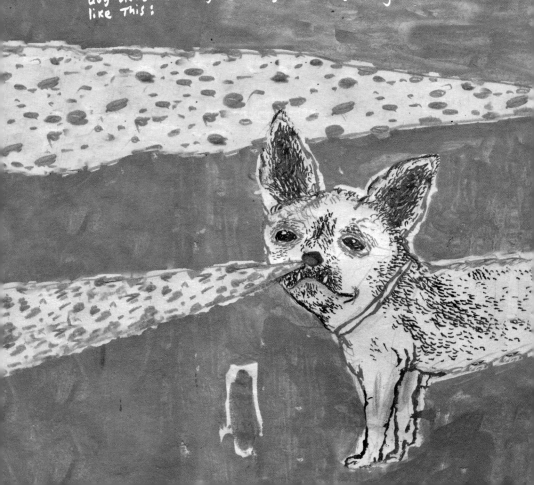

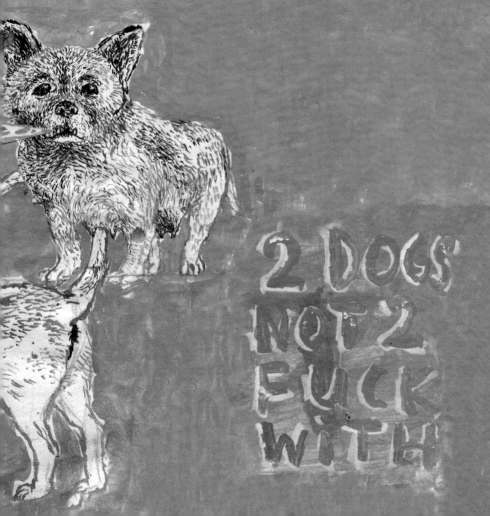

#1. YELLOW DOG (Not purebred, and must have long legs)
#2. BLACK DOG
#3. BROWN SPOTTED DOG

pedigree hounds are only eaten in a pinch.
because they are said to leave a bad aftertaste

short mussolini sidekick mutts with underbites
are completely off the menu
Because they're nasty tasting and their
short legs aren't worth the trouble.

2 DOGS
NOT 2
FUCK
WITH

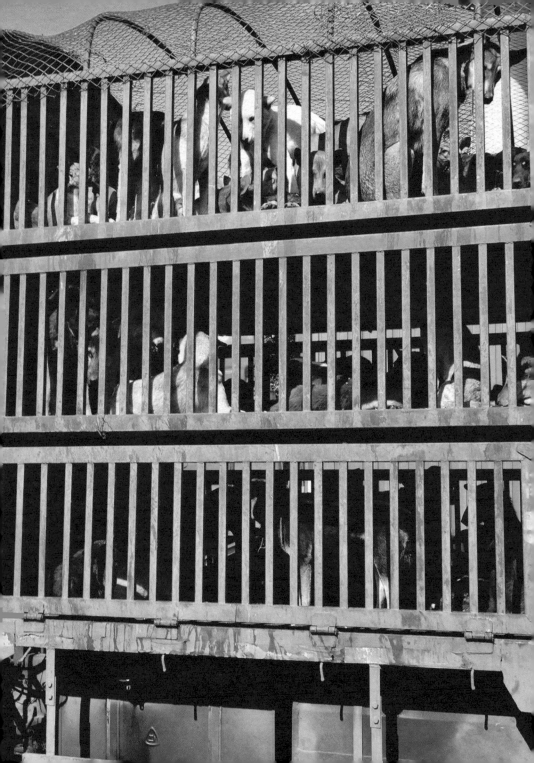

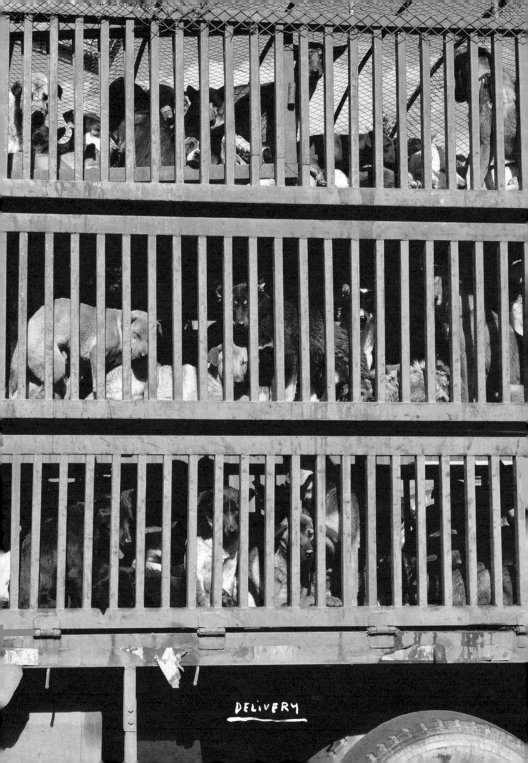

DELIVERY

attacked by a mongrel
five weeks of rabies shots

isnt such a Bad idea

20

350 × 500MM GRID 1MM NO.:C-003

Sunday

insect pills

advertising executive

theravada monks

Hongkong summary

Subway snoozers

Yi minority

medicine market

moon Festival

Endangered paws

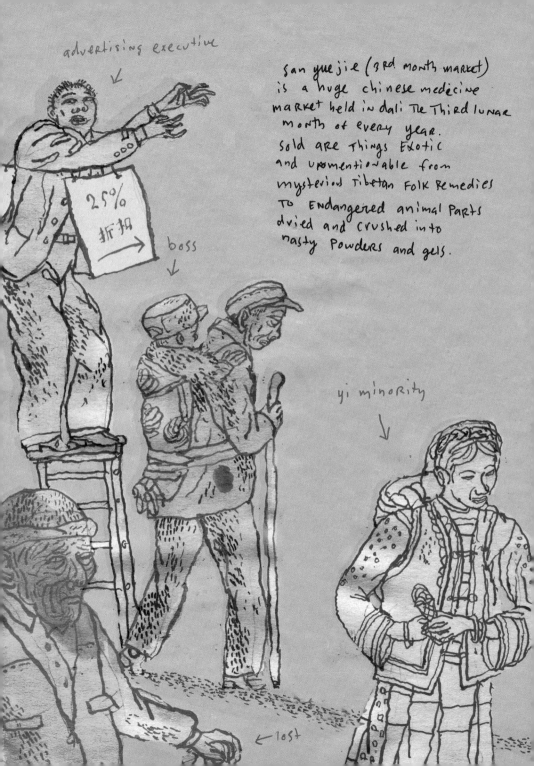

advertising executive

25%
折扣 →

boss

san yue jie (3rd month market) is a huge chinese medecine market held in dali the third lunar month of every year.
Sold are things exotic and unmentionable from mysterious tibetan folk remedies to endangered animal parts dried and crushed into nasty powders and gels.

yi minority

← lost

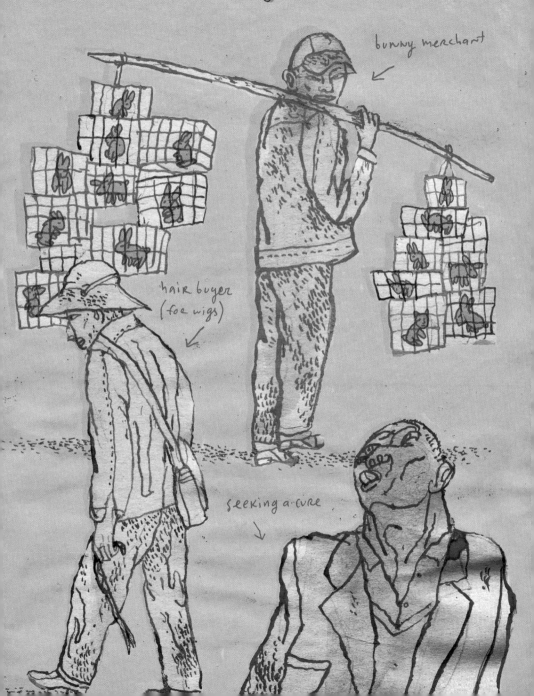

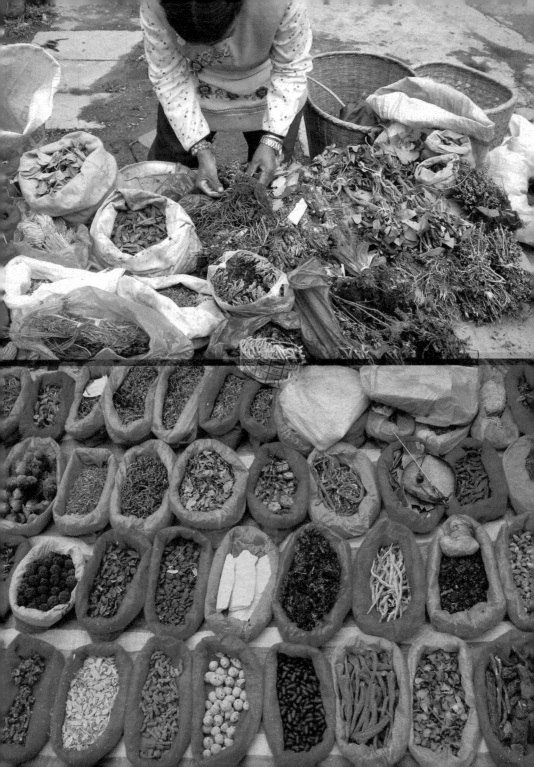

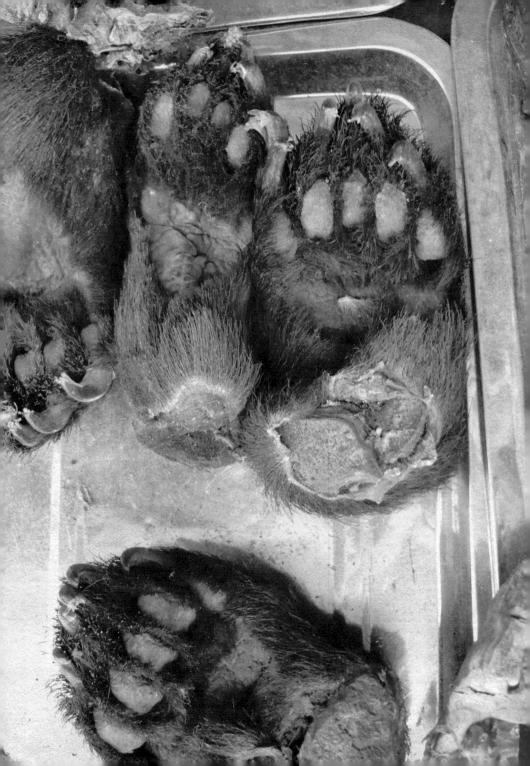

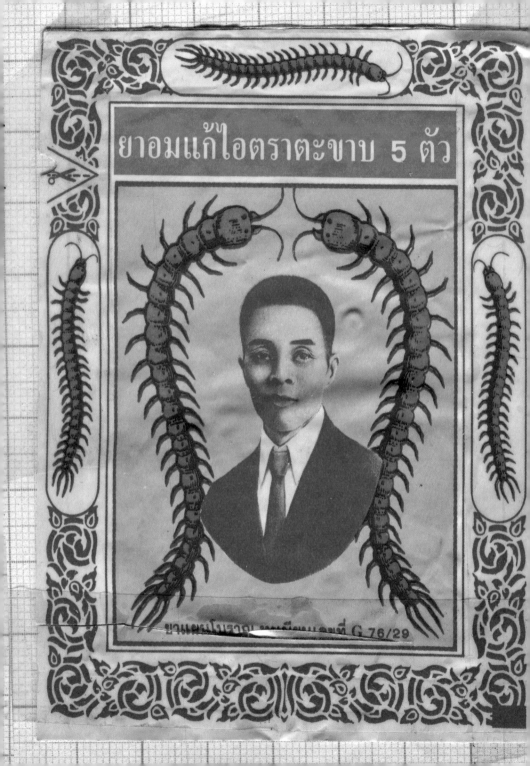

ยาอมแก้ไอตราตะขาบ 5 ตัว

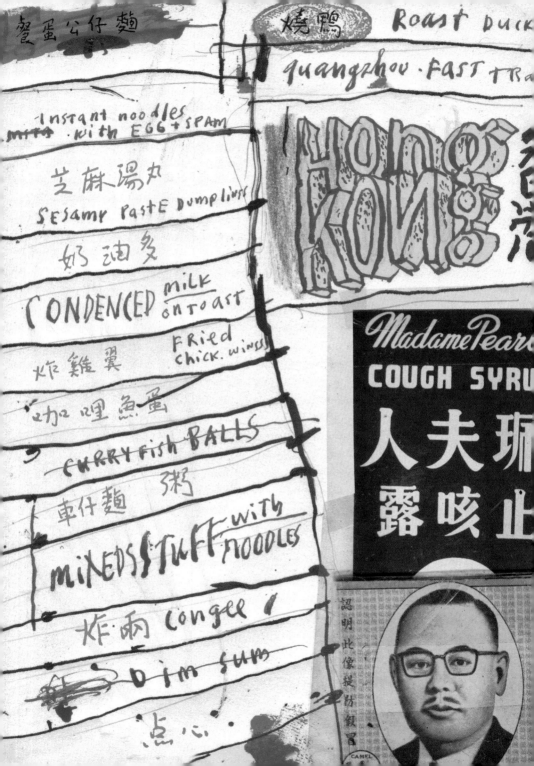

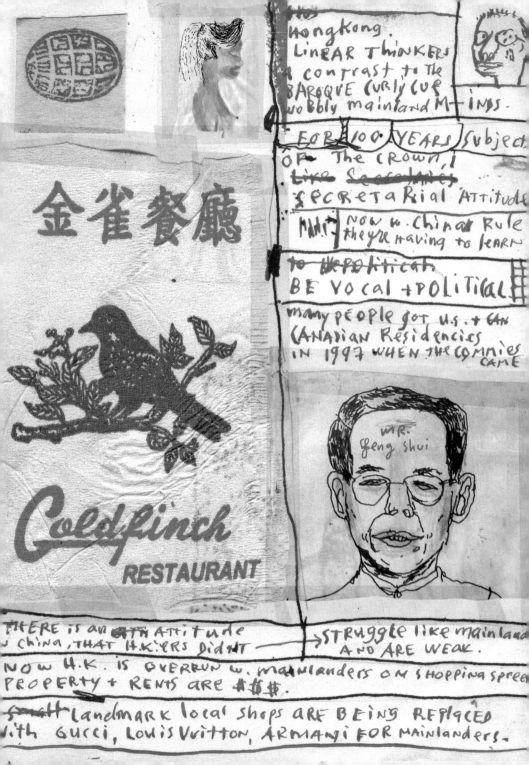

Hong Kong.
LinEAR THinkERS
a contrast to the
BAROQUE CURLY CUE
wobbly mainland M-inds.

FOR 100 YEARS subject
OF The CROWN,
like Secretaries
SECRETARIAL Attitude
now w. China rule
they're having to learn
to the political
BE VOCAL + POLITICAL

many PEOPLE got U.S. + CAN
CANADIAN Residencies
IN 1997 WHEN THE COMMIES
CAME

金雀餐廳

Goldfinch
RESTAURANT

MR.
feng shui

THERE IS an old Attitude
w China, THAT H.K'ERS DIDNT ———→ STRUGGLE like mainland
AND ARE WEAK.

NOW H.K. IS OVERRUN w. mainlanders on shopping spree
PROPERTY + RENTS ARE $$$.

small landmark local shops ARE BEING REPLACED
with GUCCI, LOUIS VUITTON, ARMANI FOR MAINLANDERS.

hong kong is one of the world's most
beautiful cities, but it is Relentless in
its insistence that you keep shopping and eating.
benches and parks are few and far between.
The subway serves as a kind of air conditioned
Resting place.

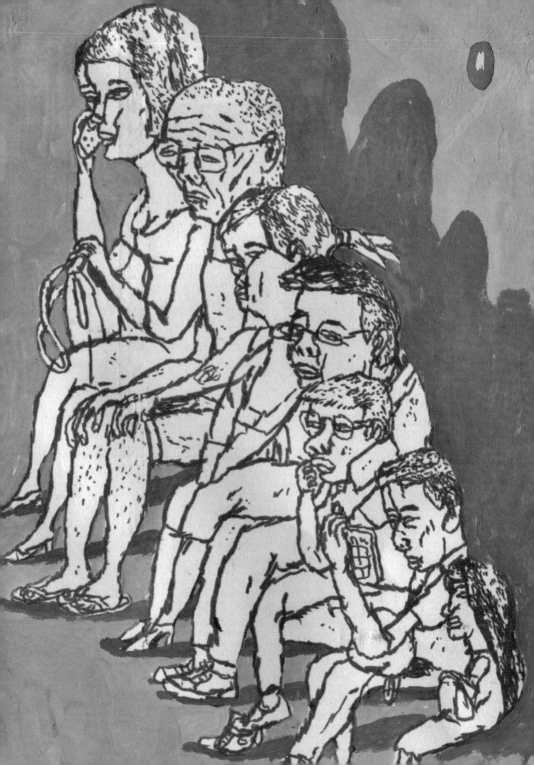

合發燉奶餐廳™

Hop Fat Milk Pudding Restaurant

Tel: 2392 2633

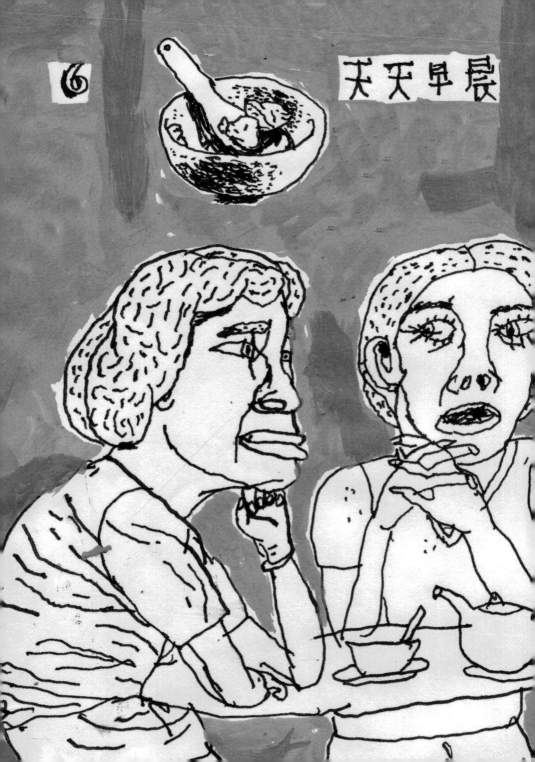

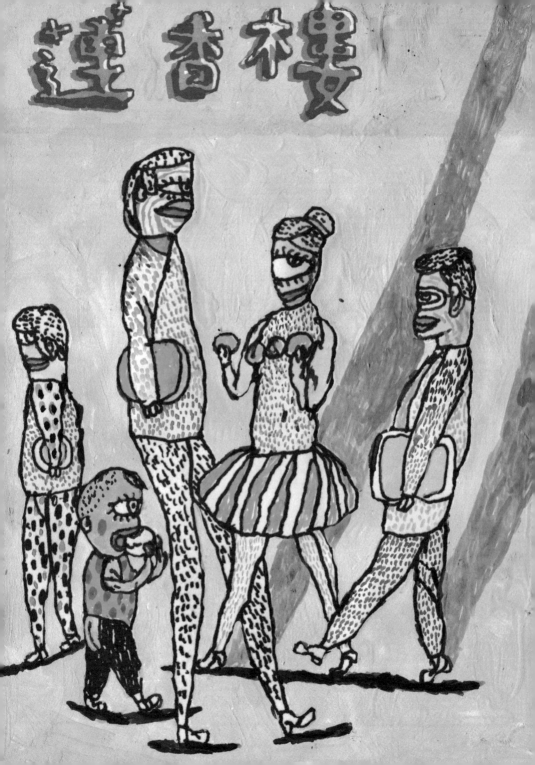

Theravada monks
in Xishuangbanna..
(south Yunnan):

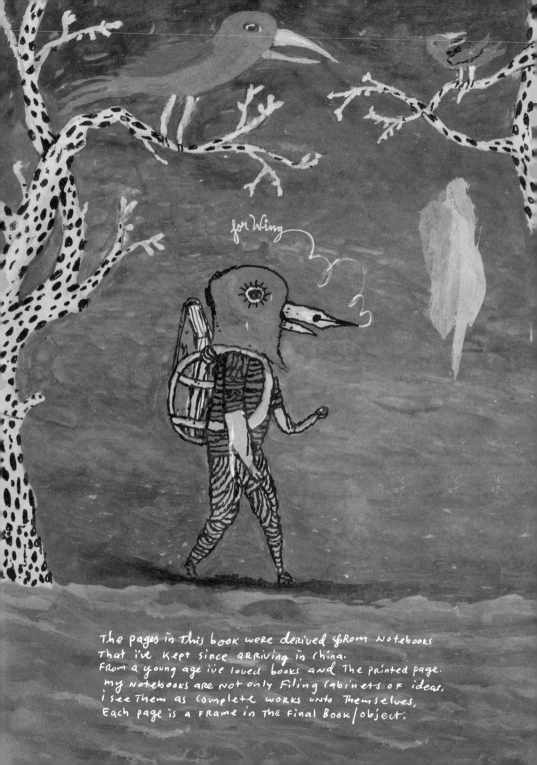

for Wing

The pages in This book were derived from Notebooks
That i've kept since arriving in china.
From a young age i've loved books and The printed page.
my notebooks are not only Filing cabinets of ideas,
i see Them as complete works unto Themselves,
Each page is a frame in the Final Book/object.

Library of Congress Cataloging-in-Publication Data available.

ISBN: 978-1-4521-2554-1

Manufactured in Hong Kong.

FSC
MIX
Paper from
responsible sources
FSC® C012521
www.fsc.org

Designed by Henrik Drescher, www.hdrescher.com

10 9 8 7 6 5 4 3 2 1

Chronicle Books LLC
680 Second Street
San Francisco, CA 94107

www.chroniclebooks.com